Postcard History Series

Rome, Georgia
in Vintage Postcards

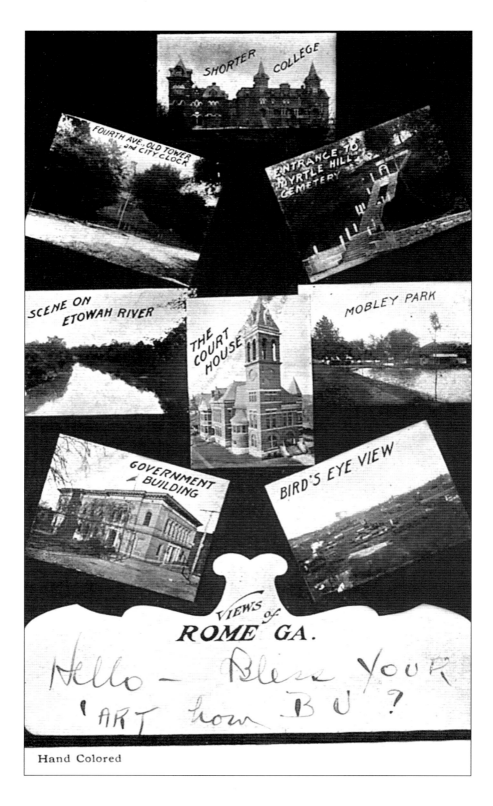

Postcard History Series

Rome, Georgia
in Vintage Postcards

Robin L. Scott

ARCADIA

Copyright © 2001 by Robin L. Scott.
ISBN 0-7385-1407-1

First published 2001.
Reprinted 2004.

Published by Arcadia Publishing,
Charleston SC, Chicago IL, Portsmouth NH, San Francisco CA

Printed in Great Britain.

Library of Congress Catalog Card Number: 2001095510

For all general information contact Arcadia Publishing at:
Telephone 843-853-2070
Fax 843-853-0044
E-mail sales@arcadiapublishing.com
For customer service and orders:
Toll-Free 1-888-313-2665

Visit us on the internet at http://www.arcadiapublishing.com

This book is dedicated to the love of my life, my best friend, and my wife, Donna.

CONTENTS

Acknowledgments 6

Introduction 7

1. Cotton and Steamboats 9

2. Historic Rome 15

3. Industry and Commerce 45

4. Hotels and Motels 61

5. Schools and Churches 69

6. Streets and Bridges 81

7. Berry College 93

8. Lindale 111

9. Cave Spring 119

Acknowledgments

To everyone that helped make this book a reality through their support, and the use of their postcards I would like to express my thanks: Dr. C.J. Wyatt, Brentz Turner, Gary Doster, Chip Tilly, Mr. Jerome Cox, The Rome Area History Museum, and Sara Hightower Regional Library.

INTRODUCTION

Located where the Oostanaula and Etowah Rivers join to form the Coosa River lies "The City of Seven Hills," Rome, Georgia.

Col. Daniel R. Mitchell, Col. Zachariah B. Hargrove, Maj. Philip Walker Hemphill, Col. William Smith, and Mr. John H. Lumpkin founded Rome in 1834. In 1833 the seat of Floyd County was in Livingston, about 13 miles south of Rome. By petition, the county seat was moved to Rome in 1835. The entire area was mapped and streets were laid out; however, they would not be paved for another 74 years.

Rome experienced great economic growth after the Rome Railroad was chartered in 1839 and began operating in 1848. Connections with the Western & Atlantic Railroad opened the way for many newcomers. By 1860 Floyd County's population had more than tripled, with the county census listing more than 15,000.

With the Coosa River navigable for 200 miles to the south and the Oostanaula 100 miles to the north, Rome became the center of commerce in Northwest Georgia. Steamboats were familiar sites on the rivers surrounding Rome, carrying passengers, cargo, and mail. The main cargo and the "lifeblood" of trade in Rome was cotton. Wagons were loaded with the unginned bales and brought to Rome to be sold. Many men became wealthy buying and selling this "staple of trade."

With the coming of the Civil War, many young men would march off to fight with the Rome Light Guards under the command of Capt. E.J. Magruder. Rome, however, would not escape Sherman's March to the Sea. Downtown buildings became hospitals for the wounded and dying. Myrtle Hill Cemetery overlooking Rome is the resting place of many Confederate soldiers who died in the conflict. It was opened in 1857 and covers 25 acres. It is Rome's second oldest cemetery and is listed on the National Register of Historical Places. Many prominent citizens of Rome's early days, including Ellen Louise Axson Wilson, the wife of Woodrow Wilson, the 28th President of the United States, are among those buried there.

Despite a drop in the population after the Civil War, Rome underwent a "re-growth." Six steamboats were again operating by 1873, and by 1878 Rome was averaging 80,000 bales of cotton on an annual basis.

The Noble Brothers Foundry built Rome's most noted landmark, the Old Town Clock and reservoir, in 1871 and the clock was installed the following year. The water tank was 26 feet in diameter and 60 feet deep. It had a capacity of 250,000 gallons of water. This water system was used until around 1900 when the new water filtration plant was built atop Fort Jackson.

Rome's first city hall was built in 1883. Electric trolleys replaced horse-drawn streetcars in 1887. During this time, hotels were built, more churches were established, and bridges were built to replace

those washed away by the flood of 1886. Textile plants were built to manufacture clothing for a growing community. Entertainment was supplied by Nevin's Opera House, bringing theatrical attractions such as minstrel shows, plays, and even symphony orchestras to Rome. Another source of entertainment was provided by local and nearby fire companies in the form of annual tournaments held on Broad Street. Enthusiastic crowds enjoyed hose-cart races, hook-and-ladder races, one and two horse races, as well as fire fighting skills.

Desoto Park, also known as Mobley Park, was the site for all types of recreation. Seventy acres of beauty included a spring-fed lake, a pavilion, picnic grounds, a casino, a baseball field, and a driving range for horse races. Rome's City Electric Railway provided transportation to and from the park for only 10¢. Darlington School, built in 1923, now occupies this site.

Rome's first public school building was completed in 1883. It was called Tower Hill School and stood next to the Old Clock Tower. Its name was later changed to Central Grammar School and finally Neely School, in honor of Benjamin Neely, the first superintendent of Rome's city school system. When Shorter College moved into a new facility in 1911, Rome High School moved into the vacated buildings. As enrollment increased, a division of students was necessary. A new high school for girls was opened in 1939 while the boys remained in the old Shorter College buildings. A co-educational system returned in 1950 and in 1958 the East Rome and West Rome High Schools were built.

Rome's history in the area of medicine goes back to around 1850 when Dr. H.V.M. Miller started work as a physician treating the Cherokee Indians. Since that time many great doctors have come to Rome to practice, including Rome's greatest surgeon, Dr. Robert Battey. After serving as a surgeon in the Confederate Army in the Civil War, he established his practice in Rome in 1869. Dr. Battey built a complex of hospital buildings in the 300 block of East First Avenue. Battey General Hospital was established in 1943 on a 160-acre site, specifically to care for disabled World War II servicemen.

The Harbin Hospital was built in 1908 with a 12-bed capacity. By 1917 a new 4-story, 40-bed brick structure was built. In 1969 a new Harbin Clinic was opened. With Floyd Medical Center and the Redmond Regional Medical Center, Rome is now recognized as the "Medical Center of Northwest Georgia."

Postcards featuring the Floyd County communities of Lindale, about four miles south of Rome, and Cave Spring, about 10 miles southwest of Rome, are also included in this collection because of their historical value and the contributions these communities have made to the overall economic success of Rome.

Picture postcards were unheard of before 1893. For this reason, many images of buildings or events before that time are only available in old photographs. Since that time, the traveling postcard photographer captured many events that can only be found on these small "snapshots." Because of space limitations, all cards depicting Rome could not be shown. For example, there are so many churches in the Rome and Floyd County area that it would be impossible to show them all in this book. In many cases postcards were not available to present here.

One
Cotton and Steamboats

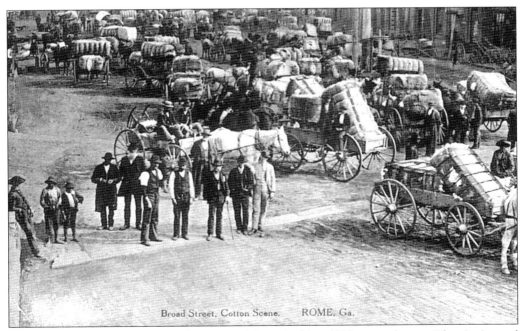

Wagons loaded with cotton crowd lower Broad Street in this c. 1910 postcard scene. The ginning and selling of cotton was Rome's principal business around the turn of the century.

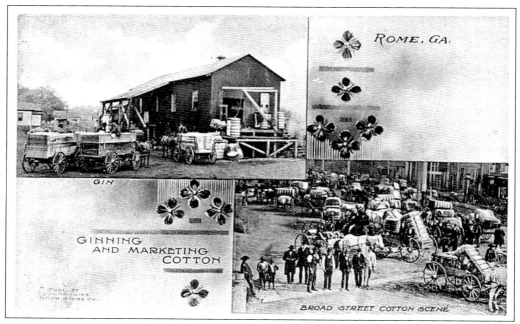

This dual-view postcard from 1905 shows an early cotton gin and the cotton market at the foot of Broad Street. Two cotton gins operating around this time were the Nichols Gin in Fourth Ward and the Dykes Creek Cotton Gin.

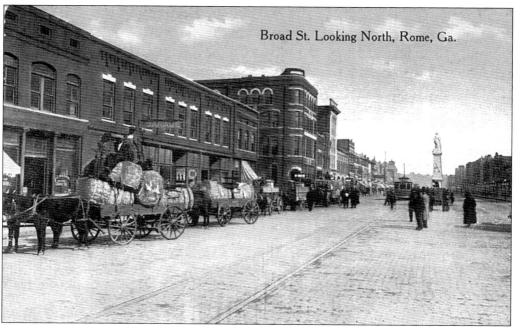

The city's cotton block is pictured in this c. 1915 view looking north up Broad Street. A streetcar makes its way past the Nathan Bedford Forrest Monument at the intersection of Second Avenue and Broad.

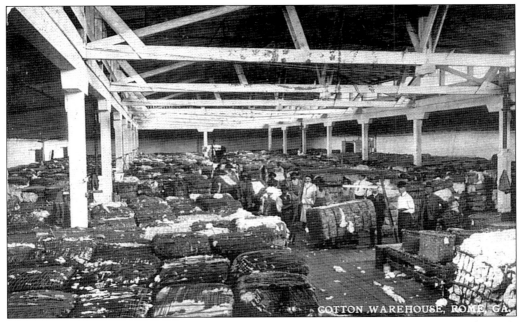

This card, postmarked in 1912, shows an interior view of the Howel Cotton Company Warehouse in Rome. Other cotton factors were operating around this time, including Montgomery & Co., Angle Cotton Co., and Rounsaville & Brothers.

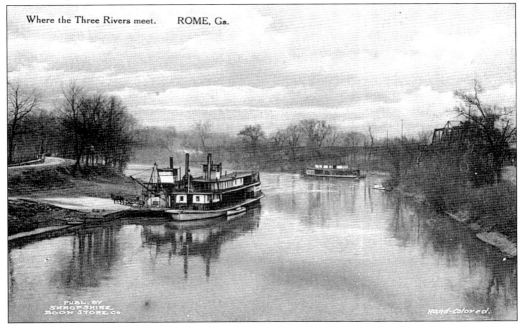

Rome's three rivers—the Etowah, the Oostanaula, and the Coosa—made her the center of Northwest Georgia for the cotton trade. Six steamboats were operating out of Rome by 1873 and by 1888 over 80,000 bales of cotton were being produced annually. Shropshire Book Store published this hand-colored view.

11

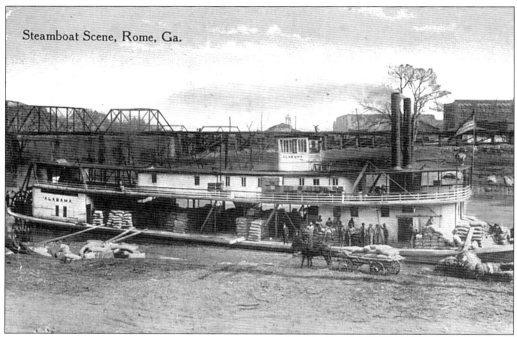

The steamer *Alabama* takes on cargo on the banks of the Etowah River around 1915. Workers take a short break as they pose for the photographer on the decks. The Central of Georgia Railroad trestle is in the background.

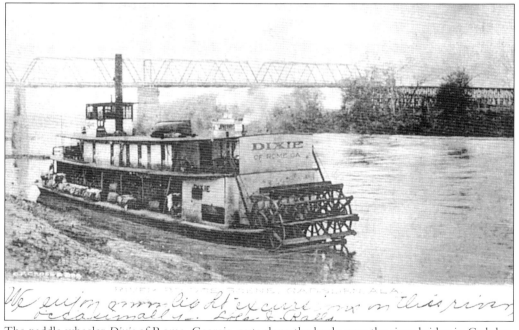

The paddle wheeler *Dixie* of Rome, Georgia, rests along the banks near the river-bridge in Gadsden, Alabama. In addition to being a cargo vessel, the *Dixie* was also used to carry passengers on Sunday afternoon excursions.

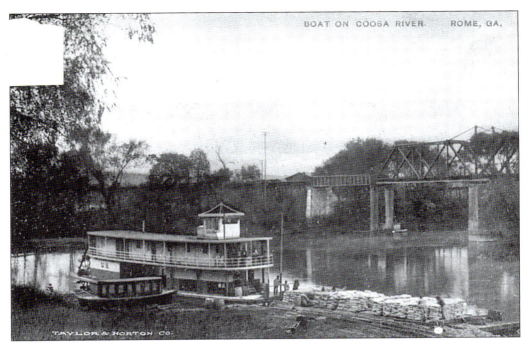

In this hand-colored view published by Taylor and Norton Drug Company, a small steamer is docked on the banks of the Coosa River around 1910. The U.S. emblem on the engine room identified it as a mail carrier.

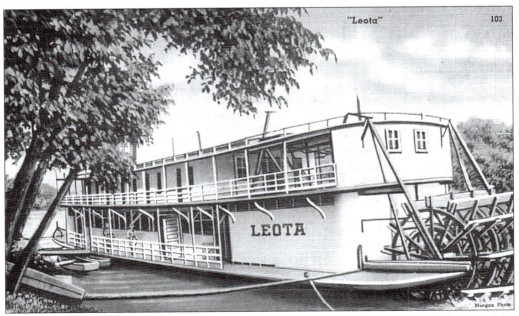

The steamboat *Leota* was the last of the old paddle wheelers on the Coosa River. Originally named the *Annie M*, this government-owned dredging boat kept the river channels clear of snags and debris. It was 148 feet in length and 28 feet wide. It sank in 1945.

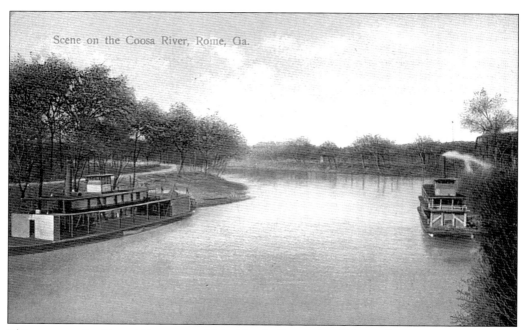

This scene on the Coosa River was published by the International Postcard Company of New York and shows two empty steamers ready to be loaded with cargo. It was mailed in 1911 with the message "I have at last reached my journeys end."

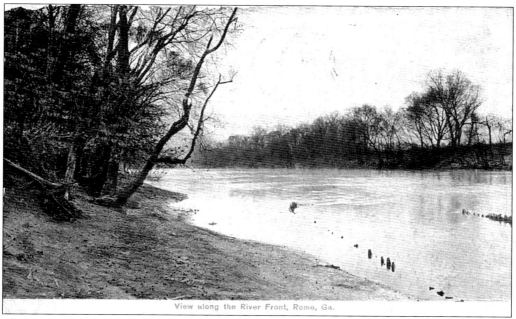

The railing of a sunken steamboat can be seen in this "View along the River Front" postmarked in 1909. Some steamboats operating in Rome around this time were the *Magnolia*, the *Hill City*, and the *John J. Seay*.

Two
Historic Rome

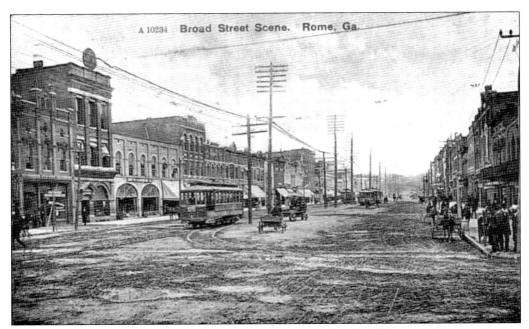

Streetcars of the Rome Railway & Light Company are pictured in this 1908 scene taken at the corner of Second Avenue and Broad Street. By 1911 the company operated 18 cars on 11 miles of street railway extending south to Lindale and west to Shorter College.

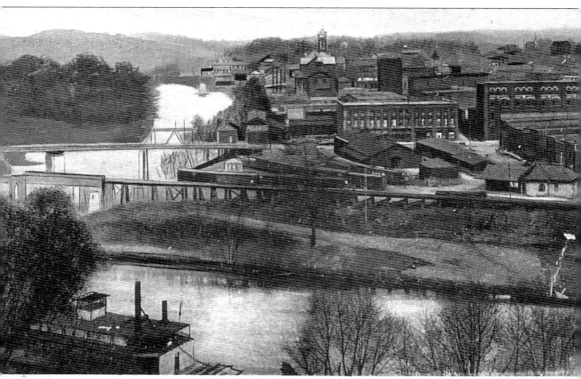

Panoramic View of

This panoramic view of Rome from Myrtle Hill Cemetery was postmarked in 1907. Many landmarks are visible including the Old Clock Tower at top center, Old Shorter College at top

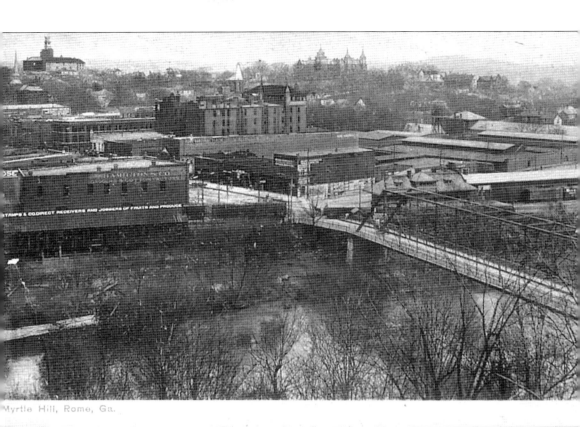

right, the Old Courthouse steeple at top left, and the Broad Street Depot at bottom right.

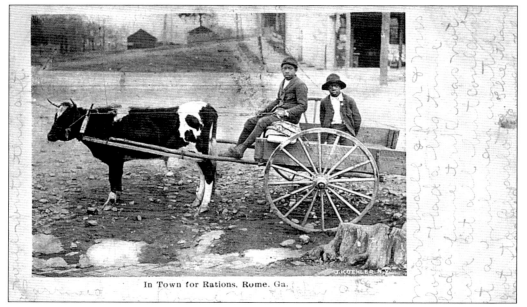

Two children, "In Town for Rations," are pictured along the dusty streets in their early means of transportation. Animal-drawn carts were common around the time this postcard was mailed in 1906. Streets would not be paved in Rome until 1908.

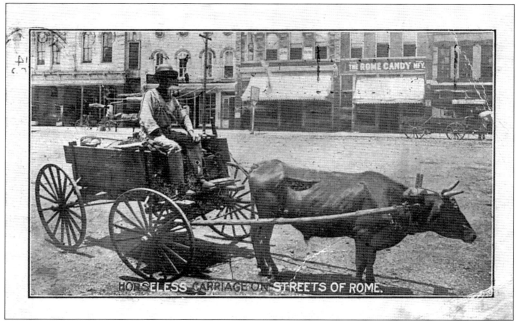

Another early postcard of a "Horseless Carriage" along Broad Street is pictured around 1914. Streets now paved with brick made travel much easier and somewhat more comfortable. Rome Candy Manufacturing Co., located at 339 Broad Street, can be seen in the background.

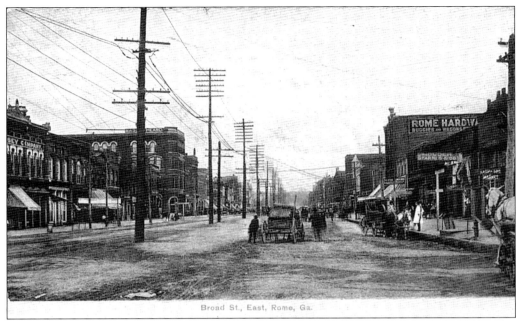

This view of Broad Street from East First Avenue shows the poor condition of downtown streets around 1907 before brick paving began the following year. After heavy rains, wagons would sometimes sink up to their axles in mud.

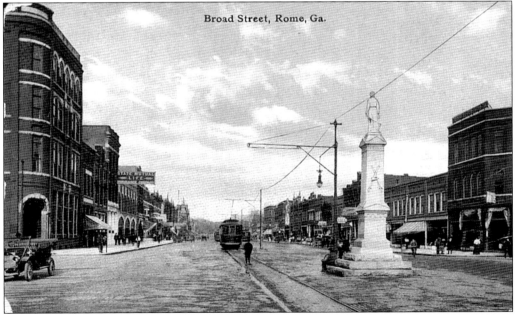

A pedestrian rests on the Forrest Monument at the intersection of Broad Street and Second Avenue as streetcars make scheduled stops along their routes. Rome Book Store published this scene around 1912. The First National Bank building at 201 Broad is at left.

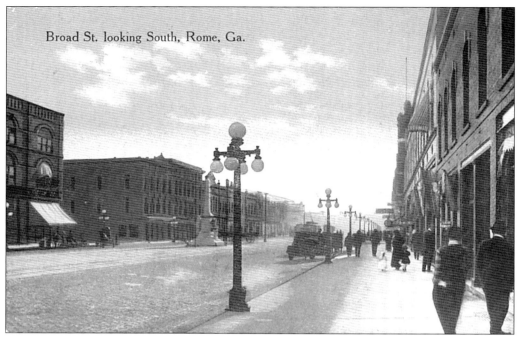

Elaborate street lamps line the sidewalks along Broad Street's 300 block in this c. 1915 view published by S.H. Kress & Company. The Monument to the Daughters of the Confederacy, erected in 1910, can be seen at left center.

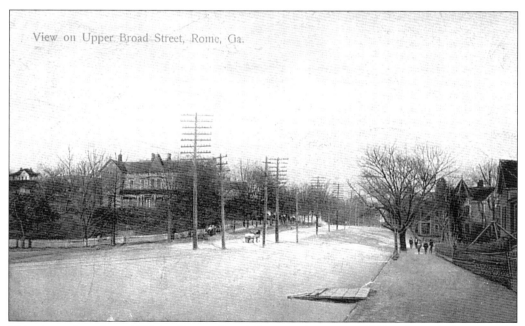

This view taken about 1908 is of upper Broad Street at the corner of West Seventh Avenue. The home at left is that of Col. Daniel S. Printup at 707 Broad Street. It was located on the site of today's Citizens First Bank.

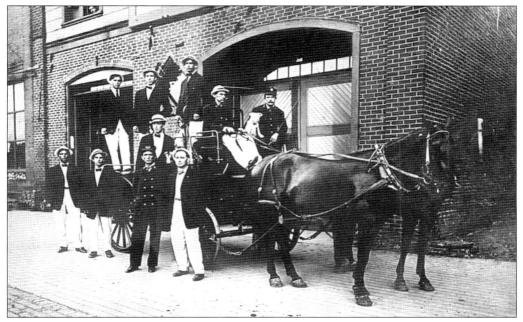

The Rainbow Steam Fire Engine Company Number 1, located at 510–512 Broad Street, was organized on April 6, 1868. Horse-drawn fire wagons like the one pictured here in this c. 1908 photo were not used until the 1880s. Before that time steam engines were hand drawn to fires.

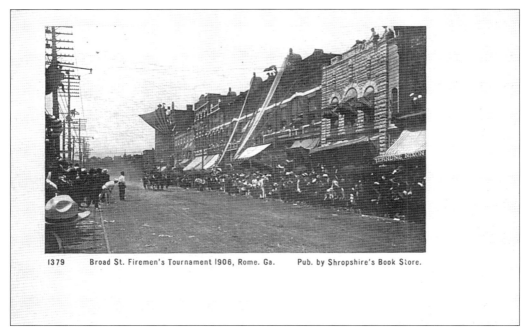

Shropshire's Book Store published this view of the 1906 Broad Street Fireman's Tournament. Visiting firemen from surrounding cities competed in speed trials, hook-and-ladder races, and hose reel contests.

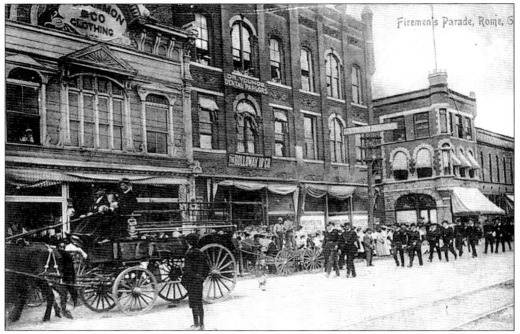

A fireman's parade and a banquet for firemen and participants preceded the tournaments held on Broad Street. These parades sometimes reached a half-mile long. This card was postmarked in 1913.

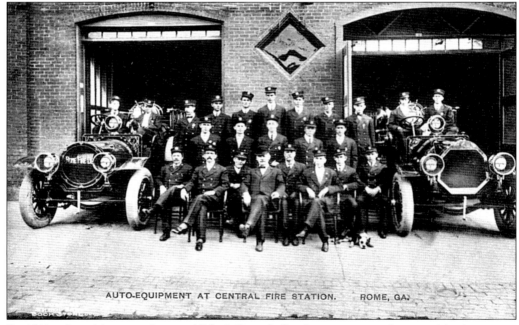

By 1911, when this postcard was published, Rome's fire department was the second in the state to become completely motorized. Proud members are pictured here at 510 Broad Street with their new auto equipment.

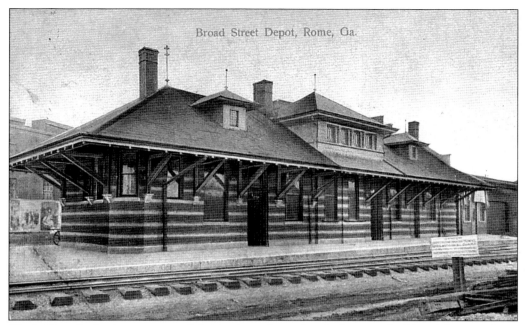

The N.C. & St. Louis passenger and freight depot, located at the lower end of Broad Street and East First Avenue, was built around 1900. As passenger train travel declined in the 1950s, this depot—like many others—fell into disuse. It was demolished in 1974 after several failed attempts to raise enough money for restoration.

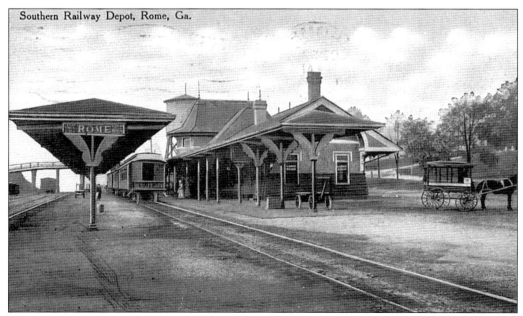

A mail carrier in his horse-drawn buggy waits for the parcels to arrive by train at the Southern Depot in East Rome. In the 1920s this depot handled 20 passenger trains on a daily basis. It was destroyed by fire on November 15, 1974.

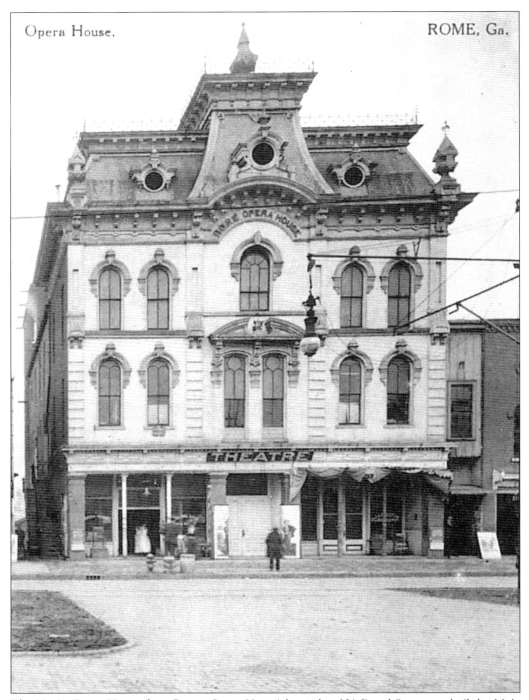

The Nevin Opera House (later Rome Opera House) located at 321 Broad Street was built by M.A. Nevin at a cost of $21,000. It opened on October 1, 1880, with a seating capacity of 1,000. For more than 35 years it hosted performances ranging from minstrel shows to symphonies. Condemned in 1915, it was destroyed by fire on December 31, 1919.

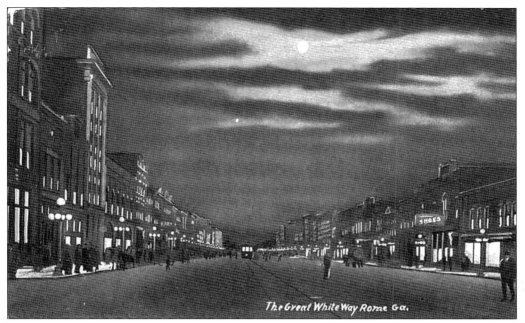

Rome Stationery Company published this c. 1910 view of Broad Street by moonlight entitled "The Great White Way." A trolley car of the Rome Railway & Light Company can be seen at center, with tracks running the length of Broad Street.

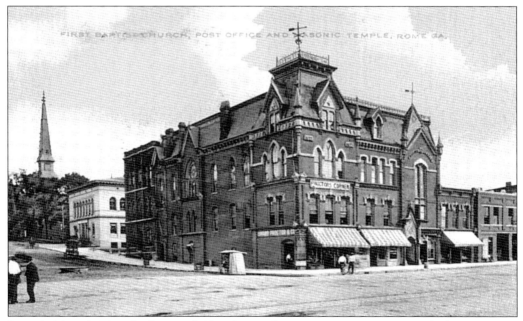

Rome's Masonic Temple, home of Cherokee Lodge No. 66, F & A.M., was built in 1877 by contractor J.A. Cooley. This four-story structure is located on the corner of Broad Street and East Fourth Avenue. The first and second floors have been occupied by retail merchants since its opening.

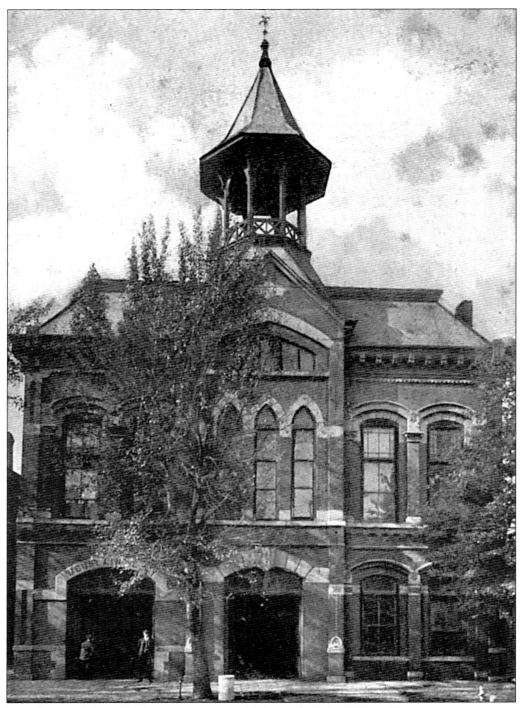

Rome's second city hall, shown here around 1907, was built in 1883 on West Fourth Avenue. It housed the mayor's office, the police department, and the Mountain City Fire Department. A storm destroyed the steeple in 1910 and it was not replaced.

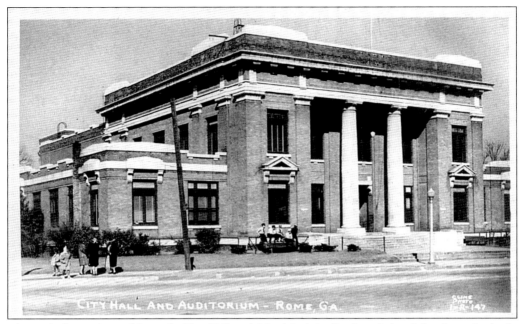

This real-photo view of Rome's City Hall and Municipal Auditorium is hand-dated on the back, March 21, 1946. The Capitoline Wolf Sculpture was removed and stored in the basement of the auditorium until after World War II because of threats to destroy the structure. It was returned to its pedestal on September 5, 1952.

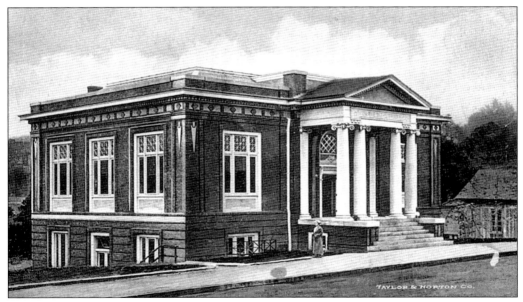

The Carnegie Library located at 607 Broad Street was built in 1911 with funds donated by Andrew Carnegie. It was also used as a meeting place for such organizations as the Junior Music Lovers' Club, the Floyd County Confederate Veterans Camp 368, and the Girl Scouts. Published by Taylor and Norton Company, this view shows the library just after its completion.

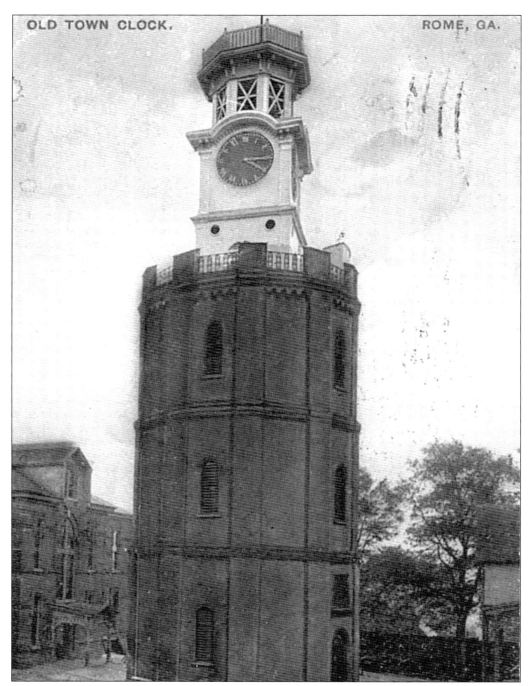

The historic Clock Tower and Rome's first reservoir is its most famous landmark. Noble Brothers Foundry built it in 1871 and the clock was added the following year. The water tank is 26 feet in diameter and 60 feet deep. It had a capacity of nearly 250,000 gallons. The wooden, clock tower is made of cypress and is 104 feet tall from the ground to the top of the railing. This view was postmarked in 1913.

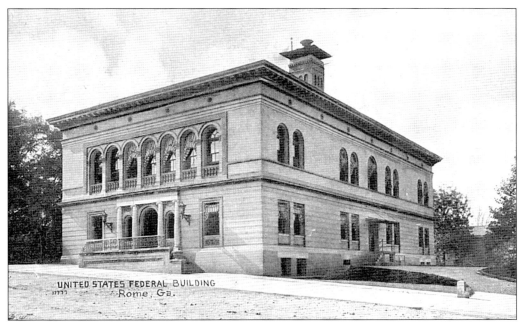

The Federal Building and Post Office, erected in 1895 at the corner of Fourth Avenue and East First Street, was Rome's first government-owned public building. It was remodeled and enlarged in 1904, 1911, and again in 1941. This postcard provides a *c.* 1908 view.

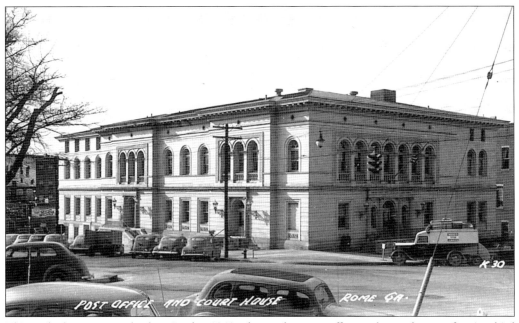

This real photo postcard taken in the 1940s shows the post office and courthouse after its third remodeling. In 1974 a new post office was built at Sixth Avenue and East First Street. The Floyd County Board of Commissioners purchased the old post office building the following year.

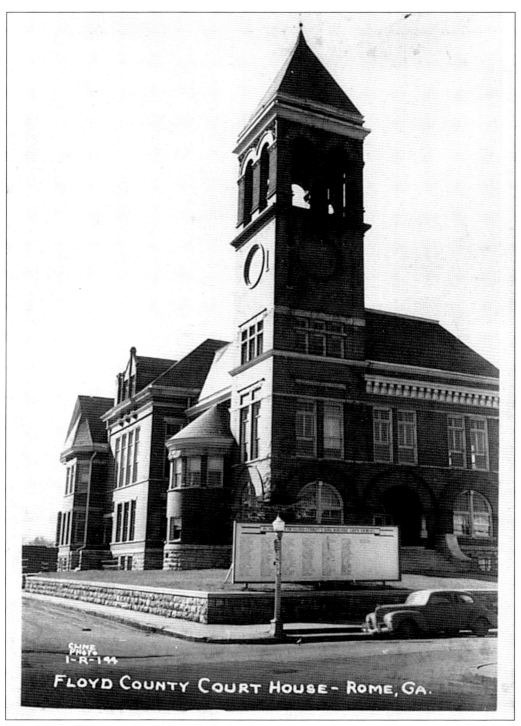

The old Floyd County Courthouse, built in 1893 at a cost of $49,935, is pictured in this photo postcard taken in the 1940s. Located at 101 West Fifth Avenue, it is still in limited use.

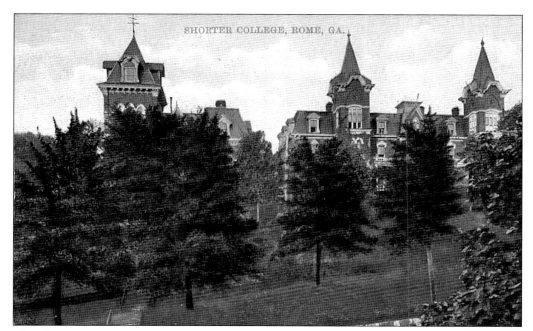

The Shorter Female College was erected between 1877 and 1879 through the generosity of Col. Alfred Shorter. It was located on Maiden Lane (now East Third Avenue). The dormitory's twin towers are at right and the administration buildings are at left. This card was published c. 1910.

When land was needed for a new Shorter College, Capt. J.L. Bass donated his home, "Maplehurst," and 155 acres of land, which at the time was valued at $75,000. With subscriptions of over $100,000, plus the sale of the old Shorter buildings to the Rome City School system, a new college was erected.

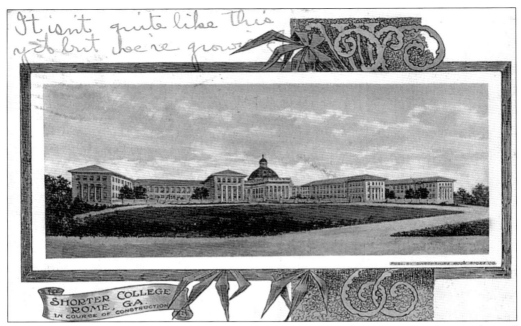

In 1911 the new Shorter College opened under the administration of Dr. A.W. Van Hoose. This card published by Rome Stationery shows how the new college was to appear when completed. However, the domed structure at center does not exist.

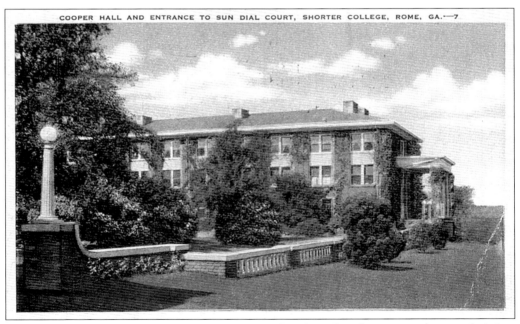

Cooper Hall, the former Music Building, was named for Alice Algood Cooper at the Founder's Day exercises October 30, 1941. Mrs. Cooper was the wife of J.P. Cooper, Rome businessman, and founder of Darlington School.

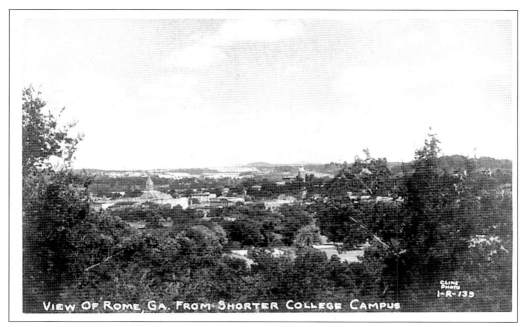

This real photo view of Rome, published by W.H. Cline, was taken from the new Shorter College campus around 1940. At the center, the city clock and Neely School can be seen. To the left, the Floyd County Courthouse is also visible.

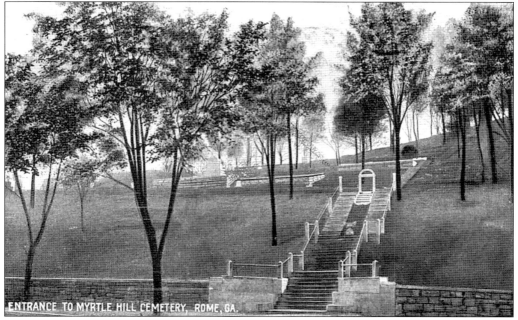

This 1910 postcard view shows the entrance to Myrtle Hill Cemetery in South Rome. Myrtle Hill covers 25 acres and was opened as a cemetery in 1857. Among those buried here are Daniel R. Mitchell, one of Rome's founders, and Ellen Axson Wilson, first lady to President Woodrow Wilson.

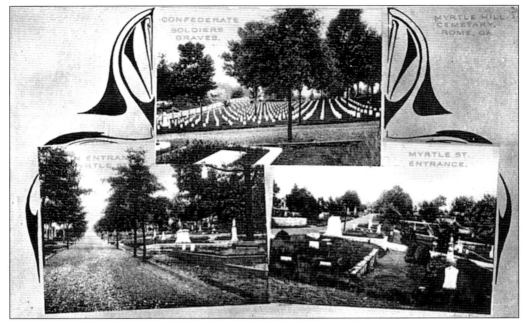

Published by S.H. Kress and Company, this c. 1910 postcard offers three views around Rome's oldest landmark, Myrtle Hill Cemetery. Lots were sold as early as 1850 and burials began in 1857 when the Oak Hill Cemetery became too small. It is listed on the National Register of Historic Places.

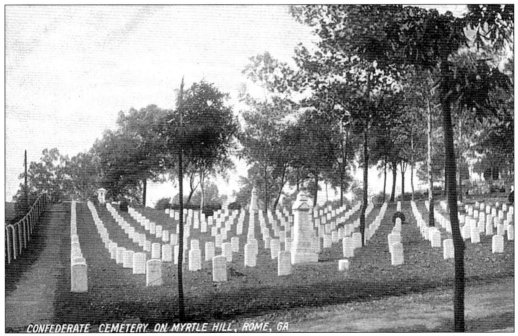

The Confederate Cemetery on Myrtle Hill contains 83 graves of unidentified and 377 known Confederate soldiers. The Holloway 10 Cent Company of Rome published this card from 1908.

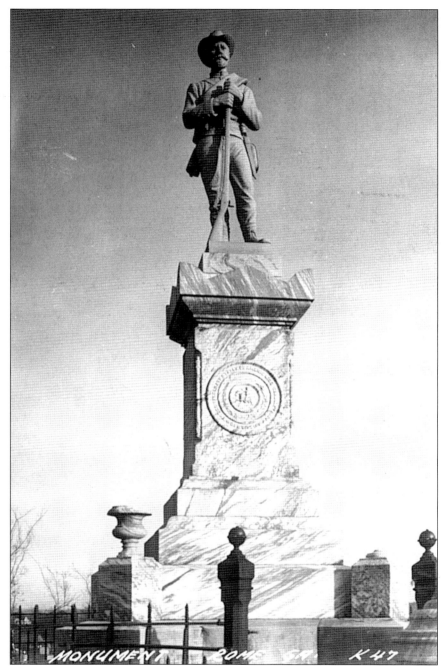
The Confederate Soldier Monument was erected and dedicated atop Myrtle Hill Cemetery on April 26, 1909. Facing towards the west, it overlooks the graves of nearly 400 Confederate soldiers who died during the Civil War. The inscription reads "To their sons they left but honor and their country. Let this stone warn those who keep these values that only their sires are dead—the principles for which they fought can never die."

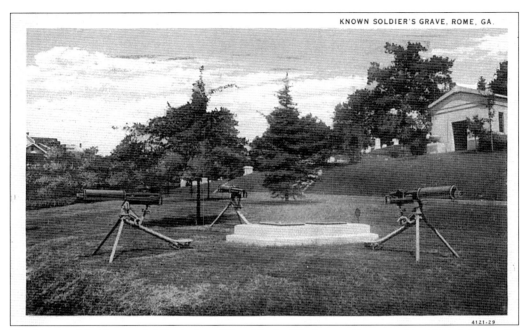

The Tomb of the Known Soldier is that of Pvt. Charles W. Graves, Company M., 117th Infantry. He was the last of the nation's dead to return to his native land and was honored by the government as representative of its known dead in the World War.

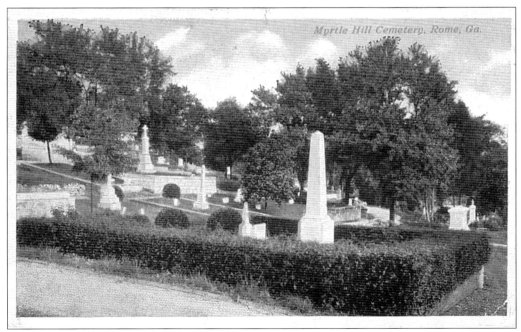

This view inside Myrtle Hill Cemetery was mailed in 1920 and shows a few of the more than 20,000 graves here. The message on reverse reads, "This is the cemetery in which President Wilson's first wife is buried. We have just visited her grave."

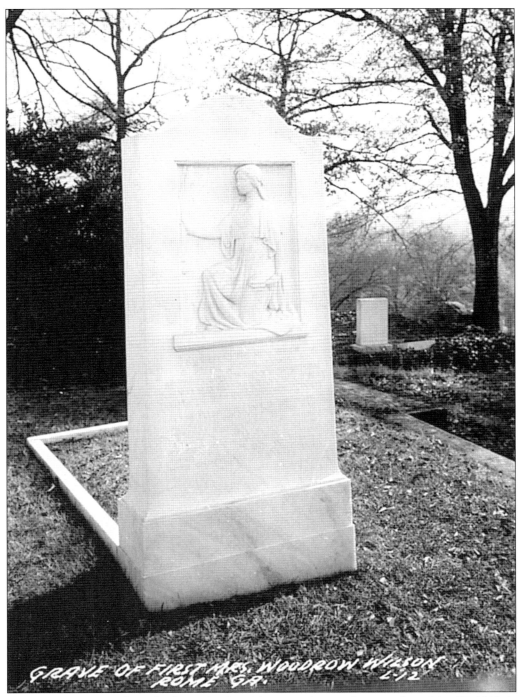

Ellen Louise Axson Wilson, the first wife of President Woodrow Wilson, was born May 15, 1860, in Savannah, Georgia, and died August 6, 1914, in Washington D.C. She is buried in the Axson family lot in Myrtle Hill Cemetery beside her brother, Dr. Stockton Axson. The Italian marble headstone was the work of artist Herbert Adams, with an inscription from a poem by William Wordsworth.

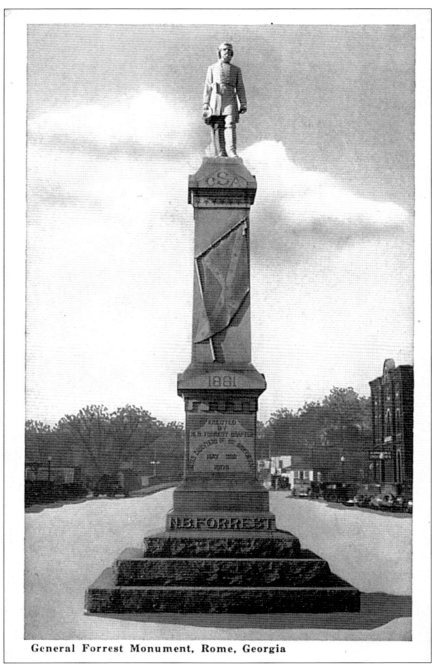

General Forrest Monument, Rome, Georgia

For his capture of Union forces near Rome in 1863, Gen. Nathan Bedford Forrest was remembered with the dedication of this monument in April of 1909. It was erected near the intersection of Broad Street and Second Avenue. It weighed 62,000 pounds and was manufactured by the McNeely Marble Company of Marietta, Georgia. It was moved to Myrtle Hill Cemetery in 1952.

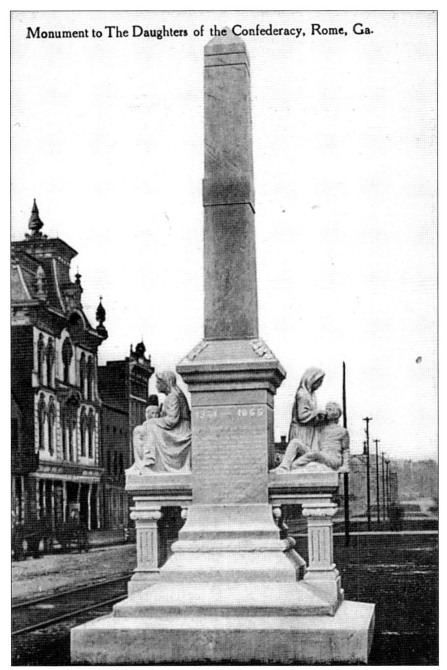

The monument to the Daughters of the Confederacy was the first ever erected to honor the heroism and bravery of southern women during the Civil War. Erected by Georgia Granite and Marble Company above the intersection of Broad Street and Third Avenue, it was dedicated on March 9, 1910. It was moved to Myrtle Hill Cemetery in December of 1952. Nevin Opera House is visible at left.

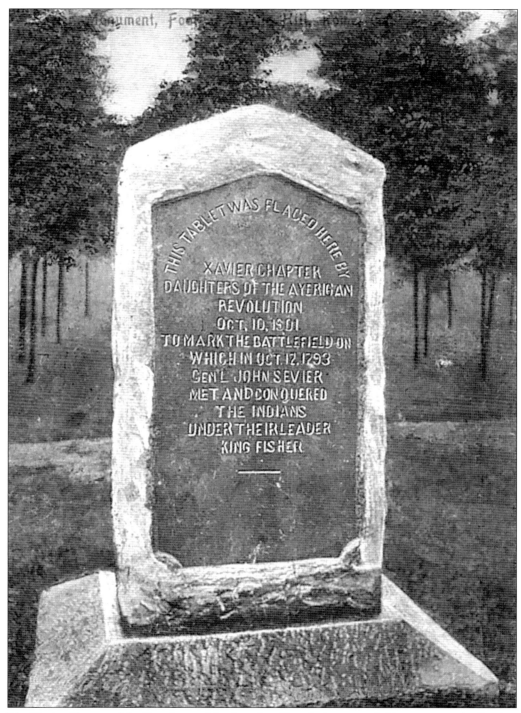

The Xavier Chapter of the Daughters of the American Revolution erected this monument in October of 1901 to mark the battlefield where Gen. John Sevier and his Tennessee Troops conquered the Indians under Chief King Fisher. This postcard was postmarked 1909.

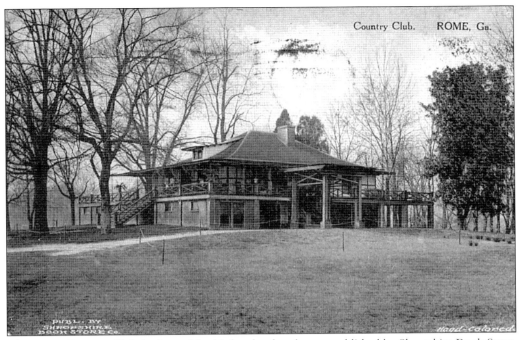

The Coosa Country Club is pictured in this hand-colored scene published by Shropshire Book Store, c. 1910. The building pictured here no longer exists; it was completely rebuilt in 1959. Dinner dances, receptions, teas, and other social events took place here.

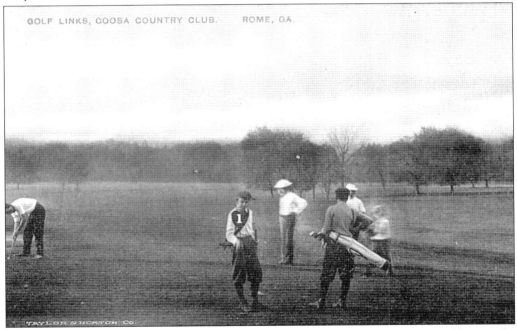

This hand-colored postcard published by Taylor and Norton Company pictures golfers on the 18-hole golf course at the Coosa Country Club around 1925. The club also offered other activities such as tennis, swimming, canoeing, and billiards.

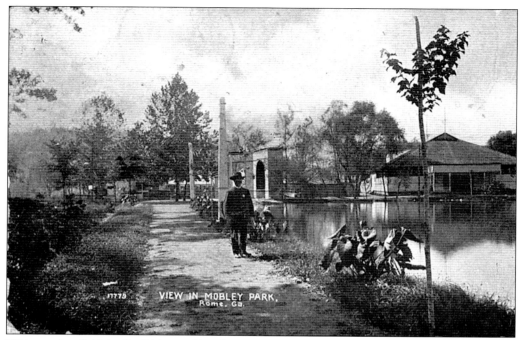

With a spring-fed lake for fishing and boating, picnic grounds, and a pavilion for plays, Mobley Park was the entertainment center of Rome in the late 19th century. The City Electric Railway bought the property and opened the park around 1894 on the site of today's Darlington School.

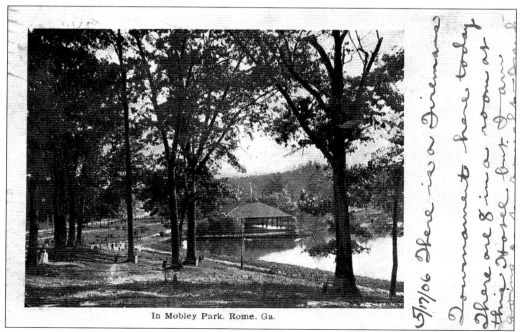

The pavilion and lake are shown at Mobley Park in this undivided back postcard mailed in 1906. It contains the message "There is a Fireman's Tournament here today."

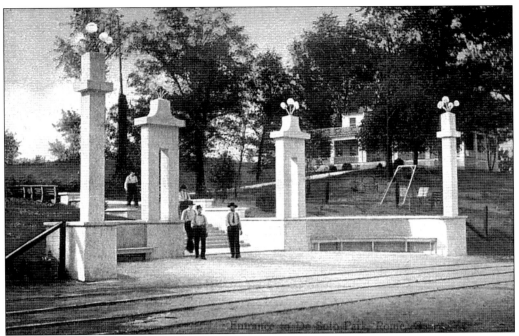

By 1908 Mobley Park was known as DeSoto Park, so named for the legendary Hernando DeSoto who, according to tradition, held campfire with the Cherokee Indians 400 years ago. This view shows the entrance to the park around 1910.

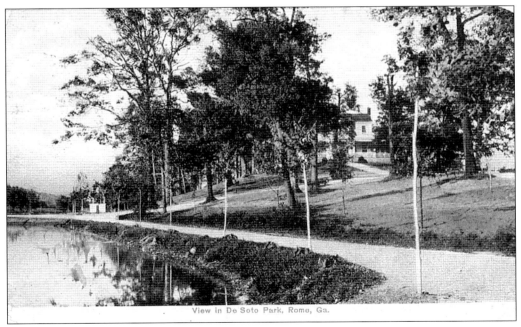

Rome Book Store published this view in DeSoto Park, postmarked in 1908. The stately "Home On the Hill" can be seen at right center. Maj. Phillip Hemphill, one of Rome's founders, built this house in 1832. It is the oldest home in Rome.

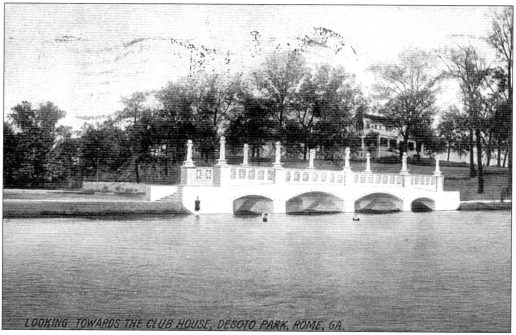

This view looking across the lake shows the old masonry bridge and the club house. The "Home On The Hill" was once used as a recreation center before Darlington School acquired the property. Since that time it has been used as the home of the president of Darlington. The postcard was postmarked 1910.

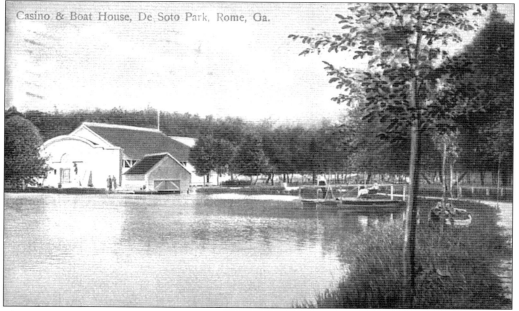

This postcard pictures the Casino and Boat House in DeSoto Park c. 1915. When Darlington School purchased the property, the brick casino building was remodeled and became the school's first gymnasium.

Three
Industry and Commerce

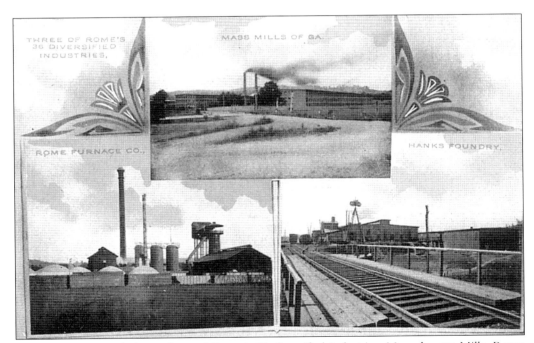

This multi-view card shows three of Rome's 36 diversified industries: Massachusetts Mills, Rome Furnace, and Hanks Foundry. When this card was published around 1915 there were more than 6,000 wage earners employed in plants around Rome.

SHOES, LEATHER and HIDES.

ROME, GA., *Nov 7* 1885

We pay this day in cash, on arrival, for

Dry Flint Hides,	11
Dry Salt Hides,	10 to 11
Green Salt Hides,	6
Green Hides,	4 to 5
Goat Skins,	8 to 10
Beeswax,	18

☞ If Hides are damp, please dry before shipping.

☞ Parties shipping Hides have no Freight, Commission or Drayage to pay. Tags furnished free.

We buy **Fur Skins** of all kinds in season.

Good Damaged non-acid Hemlock Sole,	23
Good Stamp non-acid Hemlock Sole,	25 to 26
While Oak Sole,	33 to 38
White Oak Buts (heads and Bellies cut off),	42
Harness Leather,	30 to 33
Upper Leather,	40 to 50
Kips,	50 to 60
French Calf Skins,	3.50 to 4.75
French Kips,	5.00 to 5.50
Philadelphia Calf,	3.25 to 3.50
Pegs, per bushel,	1.10
Lasts, each,	15
Shoe Nails.	7
Gents Calf Gaiter Uppers (ready fitted),	1.50 to 2.50

We keep a full line of **Shoe Tools, Thread,** etc.

Our stock of **Shoes,** including Eastern and custom made, is now full, which we offer to merchants by the package or dozen at prices to compete with any Eastern city, and on reasonable terms.

We offer—

Men's Brogans,	$1.00 to 1.25
Men's Buff Bals,	1.20
Women's Split Polkas,	75
Women's Split Bals,	75
Women's Glove Kid Bals, solid Leather Insole,	1.00

Other Goods in same proportion.

M. F. GOVAN & CO.,
Wholesale Dealers in Boots, Shoes, Etc.,
55 BROAD ST., ROME, GA.

On November 7, 1885, M.F. Govan & Company sent out this advertising postal card to Shelby Iron Works in Shelby, Alabama. Wholesale dealers in boots, shoes, leather and hides, Govan and Co. was located at 55 Broad Street.

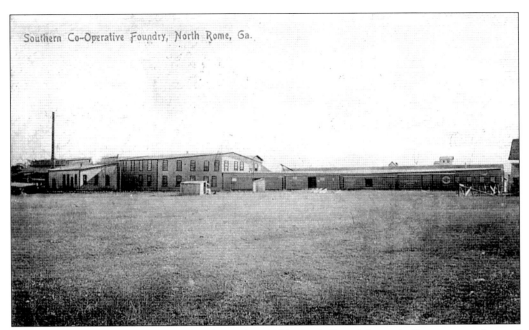

The Southern Co-Operative Foundry, located at 1903 North Broad Street in Rome, manufactured high-grade stoves, ranges, heaters, grates and hollow-ware. Along with two other stove factories in the Rome area, 60,000 stoves a year were being produced annually in 1911.

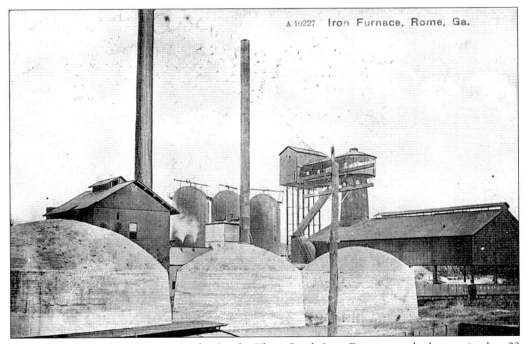

One of the largest iron furnaces in the South, Silver Creek Iron Furnace smelted ore mined at 23 different places around Rome. Bauxite, used in the production of aluminum, was very abundant in Rome. This card was published around 1910.

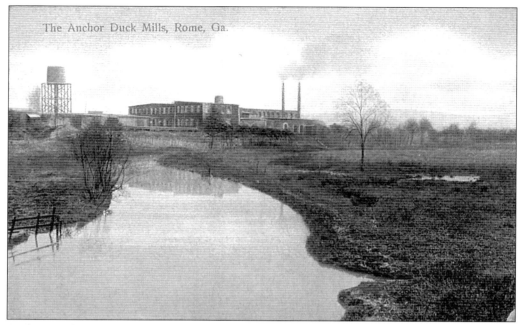

Anchor Duck Mills opened in Rome in 1901 and by 1911 had increased capacity by more than 15 times its original capital. With its own water plant and a mill village with 60 houses for its employees, Anchor Duck led the South in the production of cotton duck products.

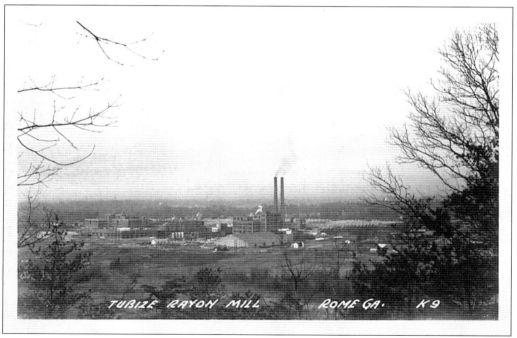

This real photo postcard shows an aerial view of the Tubize Rayon Mill that opened in Rome in 1929. It was sold to Celanese Corporation in 1945 and phased out the production of rayon in 1967, switching to an acetate yarn operation. The plant closed in 1977.

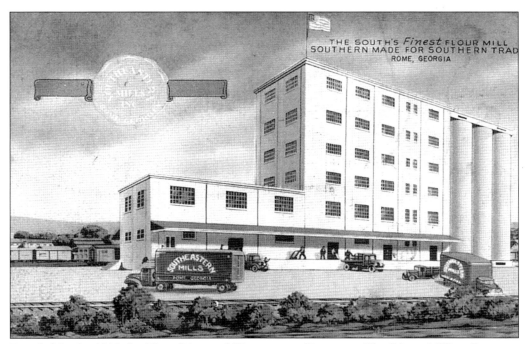

Founded in the 1930s by Theo Stivers of Chattanooga, Tennessee, The Stivers Milling Company opened on East First Avenue at the site of the old Noble Foundry. With the slogan "Southern Made For Southern Trade," it is still in operation today as Southeastern Mills.

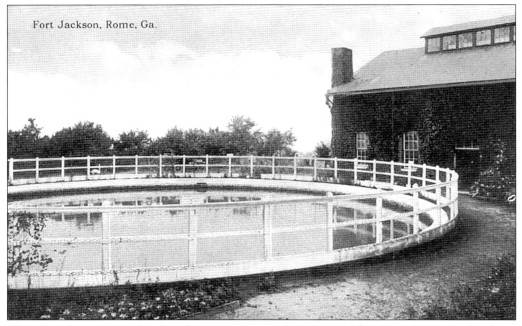

The Fort Jackson Water Filtration Plant was constructed in 1892, 200 feet above the city, and replaced the old reservoir system on Clock Tower Hill. Three million gallons of water are pumped into the reservoir daily. It was opened for use in 1900. S.H. Kress published this card in 1913.

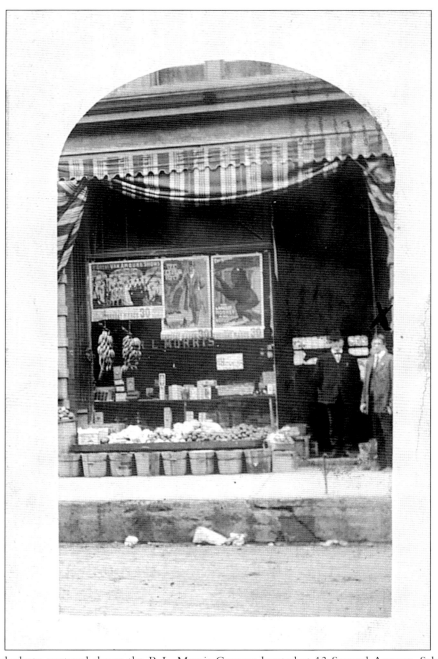

This real-photo postcard shows the R.L. Morris Grocery located at 13 Second Avenue. Sales clerk Malcolm Broach, standing at right, sent this card in 1910. Circus posters hang in the window promoting the Great Van Amburg Shows. At the time this postcard was mailed, R.L. Morris Grocery was the oldest retail merchant in Rome.

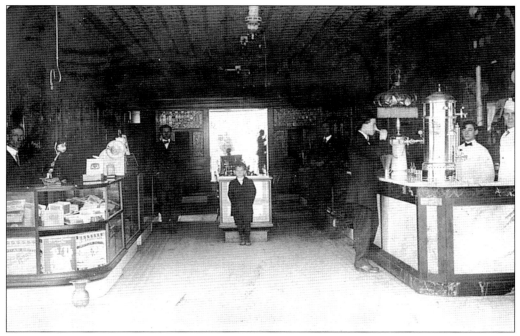

Postmarked in 1911, this vintage real-photo card pictures the Wright & Graham Drug Store, the only "24-hour-a-day" drug store north of Atlanta. It was located at Fourth Avenue and Broad Street. The photographer's reflection can be seen in the mirror at center.

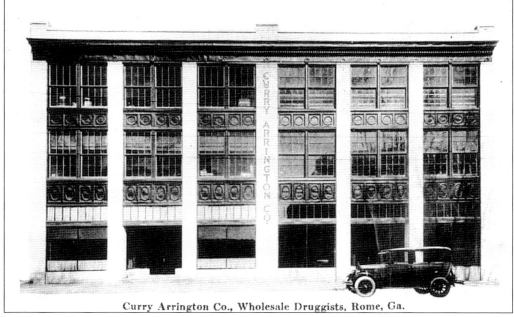

Wholesale Druggists Curry-Arrington, located at 105–107 East Second Avenue, published this postcard of their establishment in the 1930s. Their pharmacy operated at 200 Broad Street for more than 40 years before moving here in 1925. The building was torn down in 1994.

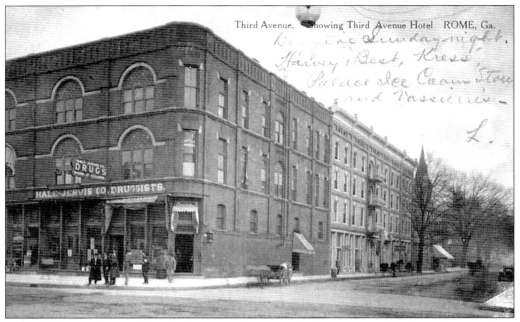

Although this card is entitled "Third Avenue, Showing Third Avenue Hotel," The Hale-Jervis Drug Co., in the left foreground, is more prominent. It was located at 300–302 Broad Street. Services ranged from prescription drugs to a paint department.

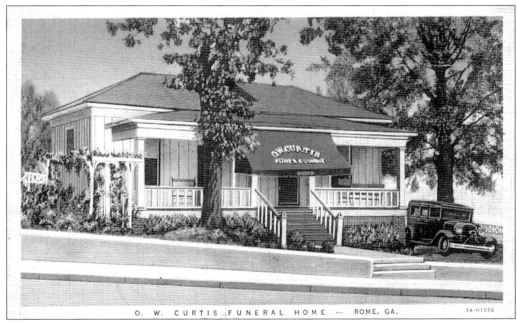

O.W. Curtis Funeral Home and ambulance service was located at 13 Forest Street in South Rome and used the slogan, "We Go Anywhere, Anytime." This linen-finish postcard view is from the 1930s.

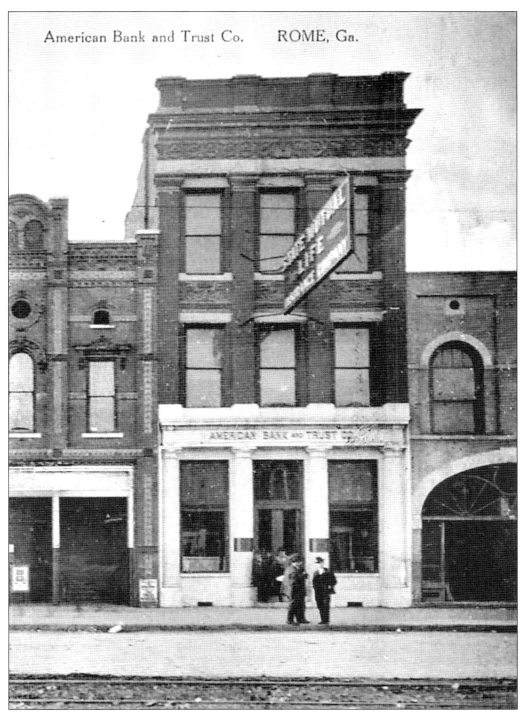

American Bank and Trust Company, located at 209 Broad Street, was organized January 18, 1909. Interior furnishings were of mahogany, marble, and brass and the front entrance was of marble and plate glass. This building was demolished in the mid-1980s.

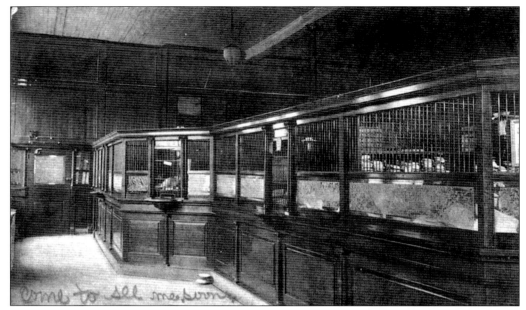

The interior of The First National Bank at 201 Broad Street in Rome is pictured on this card, mailed in 1911. Founded in 1877, the First National Bank out-lasted other banking institutions such as American Bank & Trust, Cherokee National Bank, and the Exchange Bank.

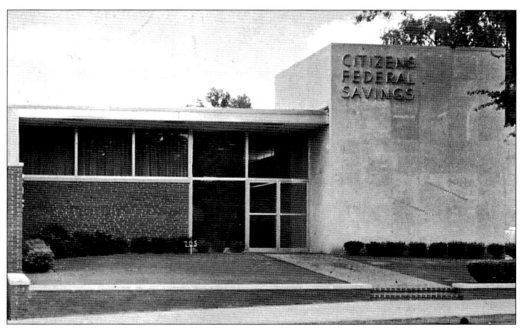

Organized in 1911 and federalized in 1937, the Citizens Federal Savings & Loan Association was located at 705 Broad Street. This building was replaced in 1974 with the present-day Citizens First Bank at the same location.

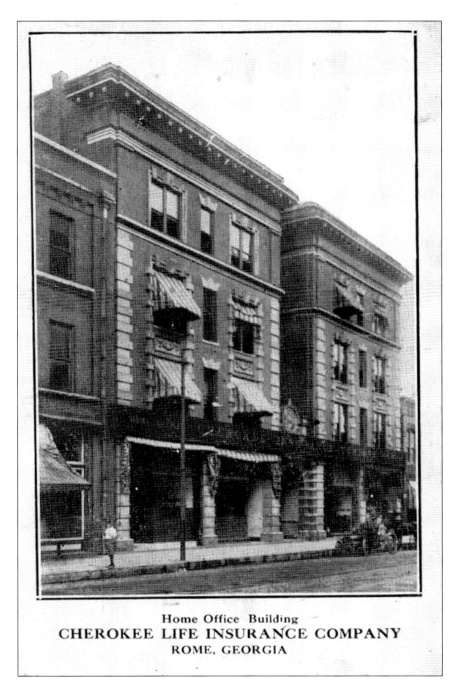

Home Office Building
CHEROKEE LIFE INSURANCE COMPANY
ROME, GEORGIA

East Second Avenue's West Building was the home of the Cherokee Life Insurance Company. When this card was published around 1911, nearly two dozen insurance companies were represented in the West Buildings. These buildings still stand, almost structurally unchanged.

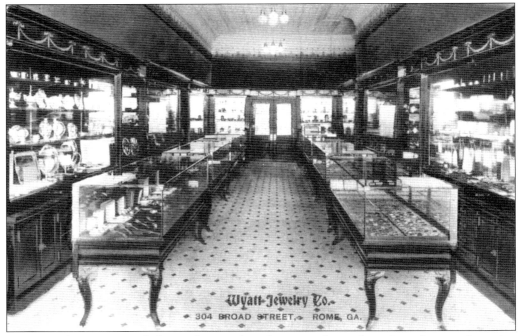

Wyatt Jewelry Company, dealers in fine jewelry, silverware, diamonds, and watches, was located at 304 Broad Street. This view shows the decorative Queen Anne-designed display cases and show room as they appeared c. 1914.

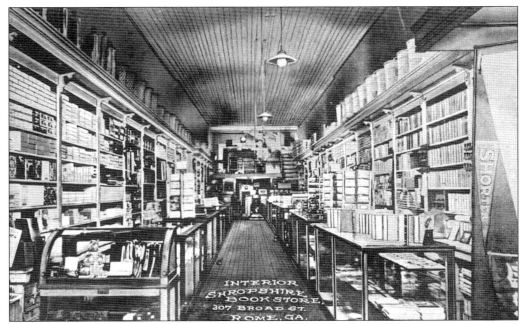

Shropshire Book Store located at 307 Broad Street carried books, periodicals, office supplies, and "a large stock & best inducements to the trade." The interior view of this c. 1910 card also shows a postcard rack on the counter at left. Shropshires published many postcard views of Rome.

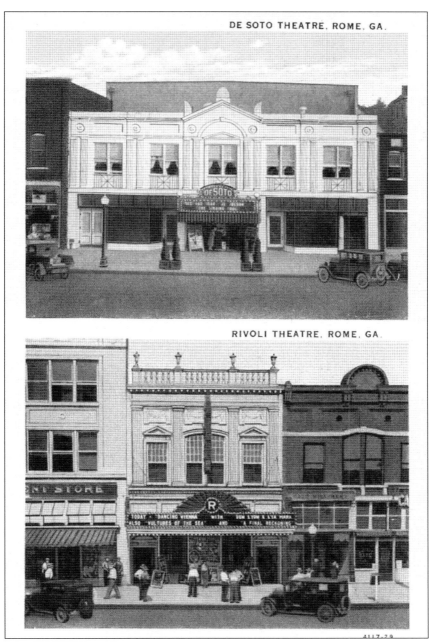

This card pictures both the DeSoto and Rivoli Theatres c. 1920. O.C. Lam Sr. owned and operated both theatres. The DeSoto was located at 530 Broad Street and the Rivoli at 225 Broad Street. The marquis for the DeSoto Theatre is still in place. The Rome Little Theatre use the building for plays and musicals.

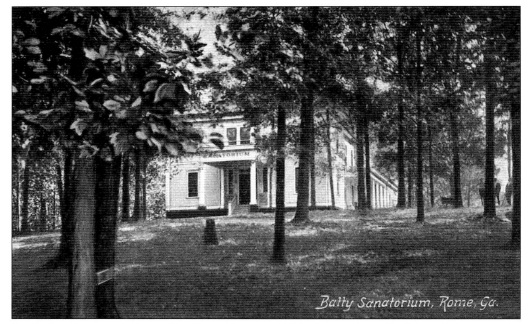

Dr. Robert Battey and his son, Dr. Henry Battey, established a complex of buildings dedicated to the treatment of women. It was located in the 300 block of East First Avenue and included the Battey Sanatorium.

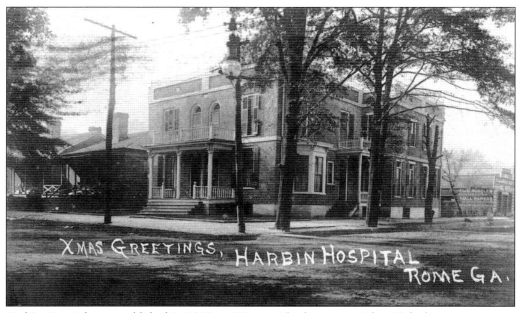

Harbin Hospital was established in 1908 at 100 East Third Avenue with a 12-bed capacity. A new four-story building was constructed in 1917 at 104 East Third Avenue with an additional three stories being added in 1920. To the rear of the hospital is the shop of sign painter Charles Ruggles at 226 East First Street.

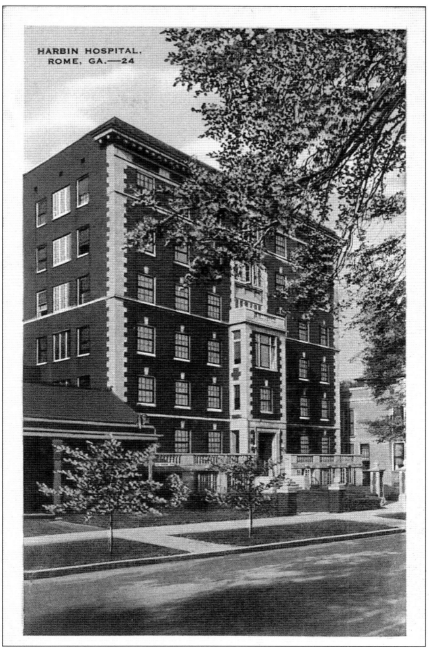

Harbin Hospital is pictured on this postcard as it appeared in the 1920s. The small building to the right is the old hospital, which was converted into a nurses' dormitory. The nurses' building was torn down in 1948. When the new Harbin Clinic was built in 1969, this building was vacated and eventually demolished in 1979.

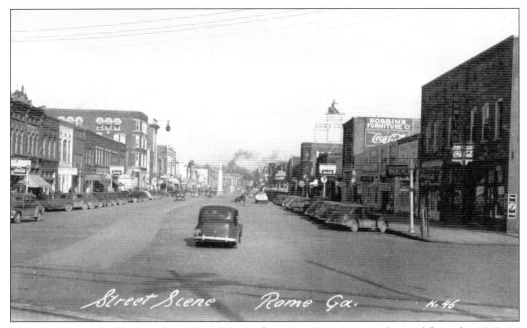

This street scene looking north up Broad Street from East First Avenue depicts life in the 1940s in Rome's business district before the days of indoor shopping malls and super department stores. Traces of streetcar tracks can be seen at left.

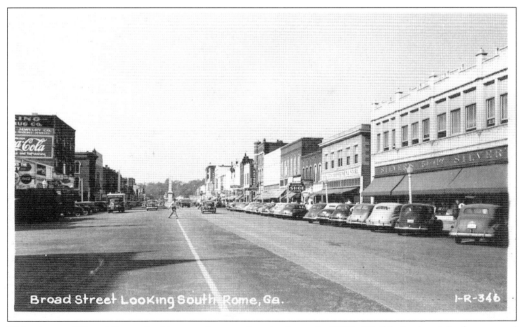

This photo of Broad Street looking south was taken in the early 1950s. Visible in the right foreground is Silvers 5¢ – $1.00 Department Store located at 321 Broad Street. The Forrest Monument and the Monument to the Daughters of the Confederacy can be seen, dating this photo to before 1952.

Four
HOTELS AND MOTELS

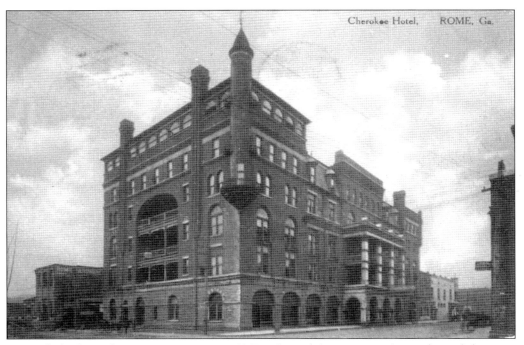

Originally built as The Armstrong House at 12 East Second Avenue, proprietors changed the name around 1900 to The Cherokee Hotel. It boasted "100 rooms and 25 private baths." It was damaged by a fire in 1921 that greatly reduced its capacity.

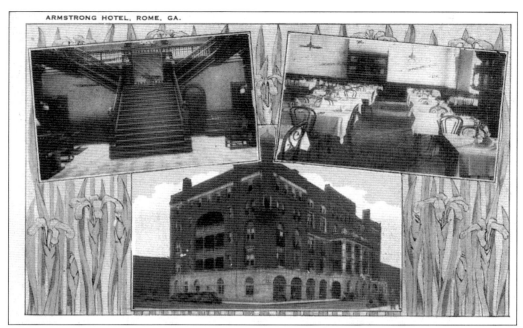

The hotel was again renamed The Armstrong Hotel in 1927, and this postcard from 1928 shows the grand staircase at left and the dining room at right. It was demolished in 1934 and rebuilt as the Greystone Hotel using the original granite blocks on the lower floor.

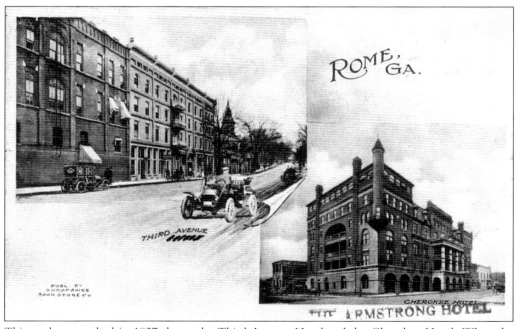

This card postmarked in 1927 shows the Third Avenue Hotel and the Cherokee Hotel. When the Cherokee Hotel was again re-named "The Armstrong Hotel" in 1927, a stamp was used at the bottom right corner in lieu of printing new cards.

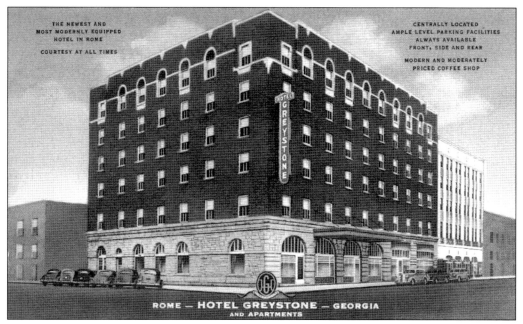

The modernly equipped Hotel Greystone located on East Second Avenue opened in 1934 with 154 rooms—30 rooms being used as apartments and 124 for hotel accommodations. A message written on the back of the card reads "A Real Nice Hotel."

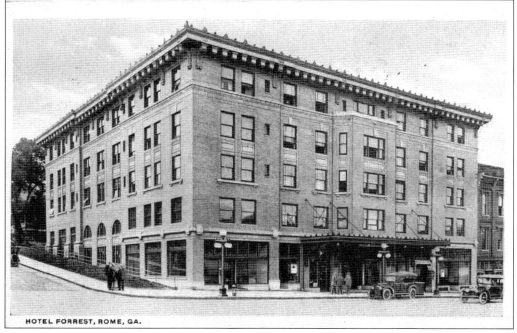

The Hotel Forrest, located at 436 Broad Street, was named for Gen. Nathan Bedford Forrest. It was built in 1915 on the site of the old Choice House Hotel. This card was postmarked 1924.

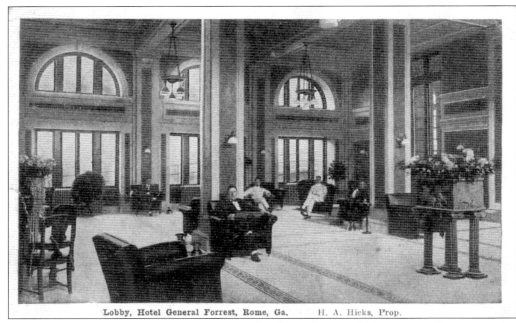

Lobby, Hotel General Forrest, Rome, Ga. H. A. Hicks, Prop.

The lobby of the Hotel General Forrest is pictured in this card postmarked in 1916, only one year after its construction. Note brass spittoons beside every chair.

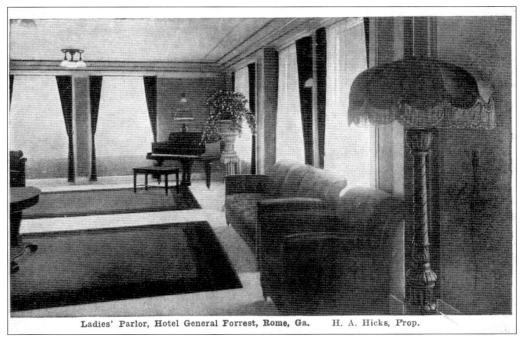

Ladies' Parlor, Hotel General Forrest, Rome, Ga. H. A. Hicks, Prop.

This interior view of the Hotel General Forrest shows the ladies' parlor and the ornate decorations of the time period. E.C. Kropp published this c. 1915 card.

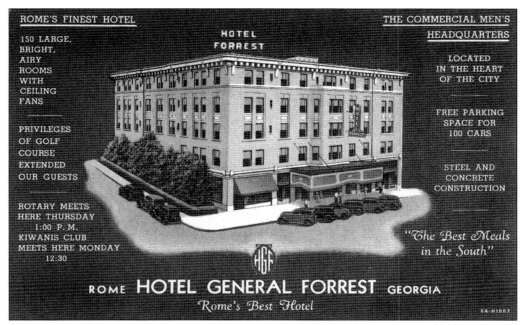

With 150 rooms and free parking for 100 cars, the Hotel Forrest claimed to have "The Best Meals in the South." When this view was published in the 1940s, L.F. Hackett was owner-manager.

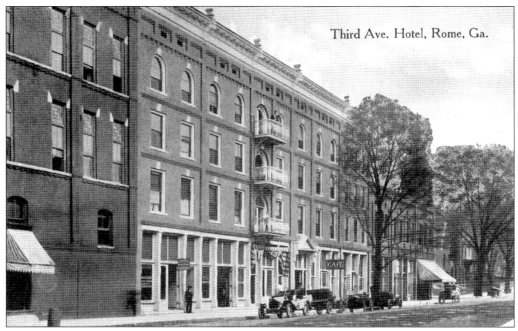

The Third Avenue Hotel was built in 1909 by Capt. J.L. Bass. It featured 60 rooms with "hot and cold running water, long distance phone and steam in every room." Rates were $1 and $2. This view is from around 1910. The Presbyterian Church can be seen at far right, just behind the trees.

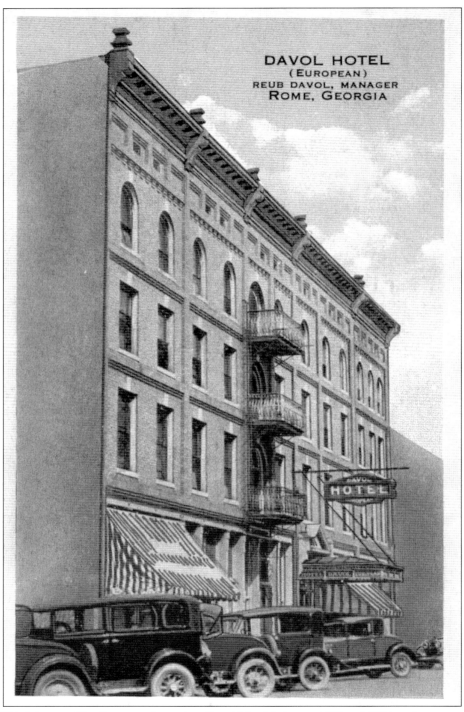

The Third Avenue Hotel's name changed to Davol Hotel between 1925 and 1931 and was operated by European businessman Reub Davol. By 1932 it was back in operation as the Third Avenue Hotel, with C.B. Willingham as proprietor. It closed in 1957.

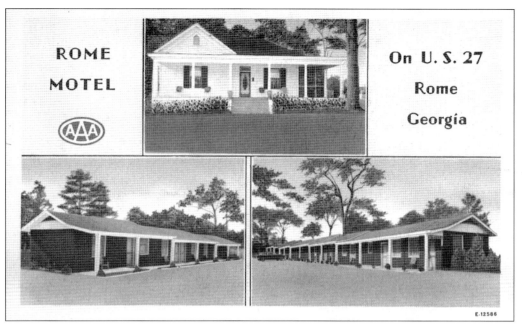

The Rome Motel, located on Highway 27, featured 16 modern hotel rooms, private tile baths, carpeted floors, and Panelray heat. The AAA-rated Plantation Restaurant adjoined the motel.

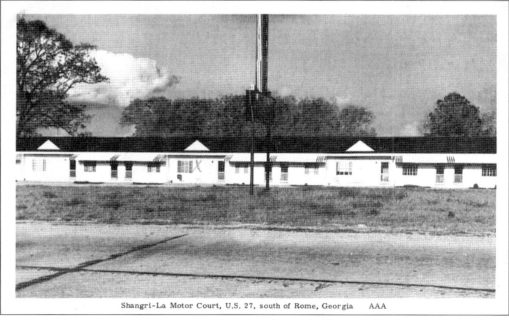

Shangri-La Motor Court is pictured along Highway 27 South of Rome in this card postmarked 1952. It was located near Floyd College on the site of today's College Inn. This card was published by Portland Lithograph Co.

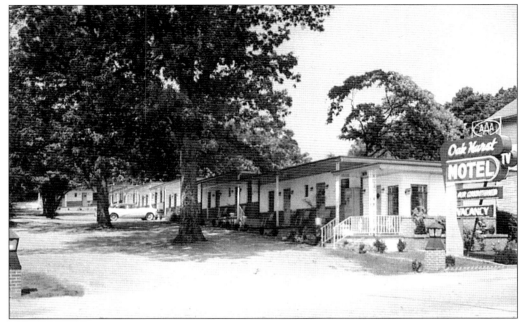

The Oak Hurst Motel with Ozzie's Steak House adjoining was located on Martha Berry Highway with 28 air-conditioned units, individually controlled vented heat, television in every room, wall-to-wall carpet, tile showers, room phones, and a swimming pool. It was owned and operated by C.W. Oswalt.

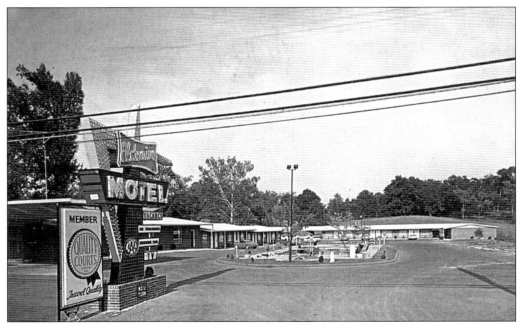

Highway 27 north of Rome was a popular location for motels in Rome. This view postmarked in 1965 shows the Elstonian Motel. It featured 21-inch Westinghouse TVs and a telephone in every room. Howard Johnson now operates a motel on the site.

Five
SCHOOLS AND CHURCHES

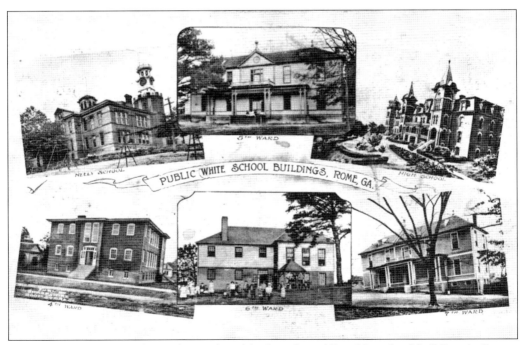

This postcard from 1914 featured a combined look at the public white school buildings in Rome. Pictured are Neely School on Clocktower Hill, Fourth Ward School located on North Fifth Avenue, Fifth Ward School located in South Rome, Sixth Ward School located in North Rome, Seventh Ward School located in East Rome, and Rome High School on East Third Avenue.

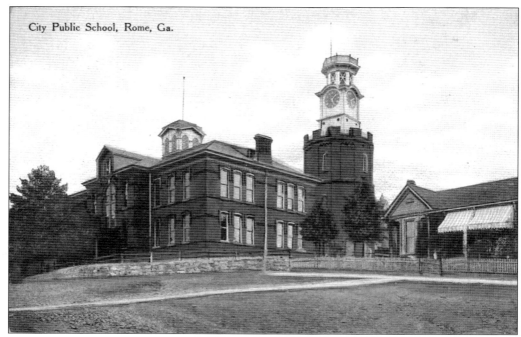

Built in 1883 as Tower Hill School, Rome's first city school building was later named after Benjamin Neely, Rome's first school superintendent. After much opposition, it was torn down in 1961. This card is hand-dated January 30, 1911, and was published by S.H. Kress & Company.

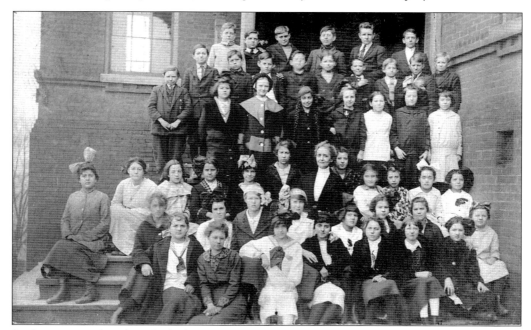

Students surround teacher Elizabeth Harris on the steps of Neely School in this *c.* 1910 photo card. By this time Neely School was a grammar school, and 80 percent of white school-age children were enrolled in the Rome public school system.

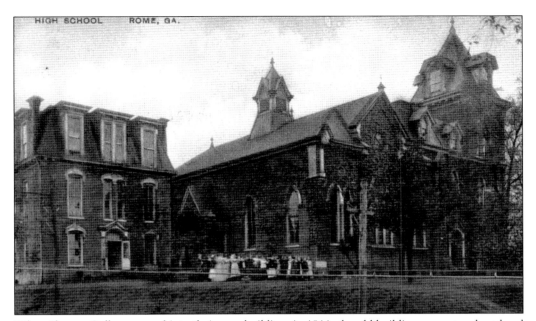

When Shorter College moved into their new buildings in 1911, the old buildings were purchased and remodeled for use as Rome High School. The first term opened here on September 4, 1911. Several fires through the years changed the appearance of the school before its eventual destruction in the mid-1980s.

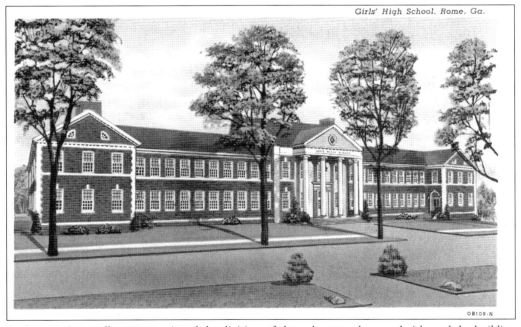

An increase in enrollment necessitated the division of classes between boys and girls, and the building of a new Girls' High School. This new school opened in 1939 at 415 East Third Avenue. The co-educational system returned in 1950, and in 1958 East Rome High School and West Rome High School were built.

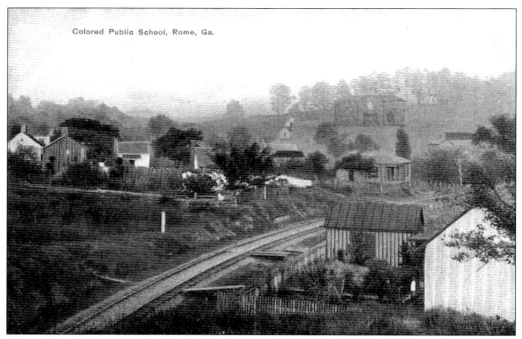

Rome's first city-owned colored public school building was constructed in 1898. It was located in the Forrestville community of North Rome, along the Western & Atlantic Railroad. The Holloway 10 cent Company of Rome published this card c. 1908.

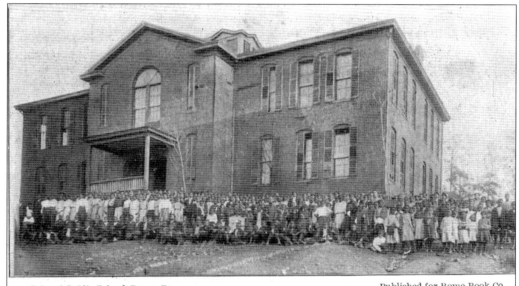

Published for Rome Book Company by Nouveau Novelty Company of Atlanta, this undivided-back postcard gives a close-up look at the Colored Public School Building with students and faculty present, c. 1905.

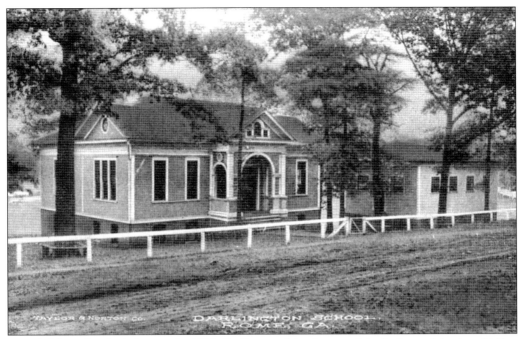

Founded by John Paul Cooper in 1905, Darlington School was originally located in the old East Rome Fire Hall at 718 East Second Avenue. This c. 1915 view shows Darlington's second home on East Ninth Street.

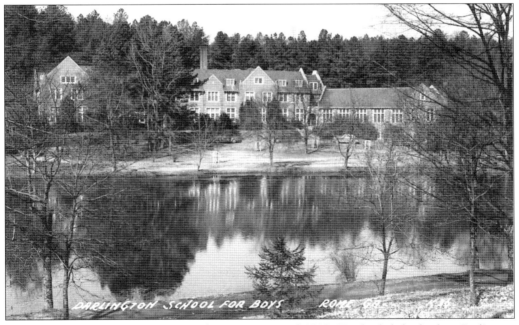

J.P. Cooper purchased the DeSoto Park property around 1915. He deeded the land to Darlington School in 1921 and the new school was built in 1923. This view looking across Silver Lake shows the main campus buildings in the 1940s.

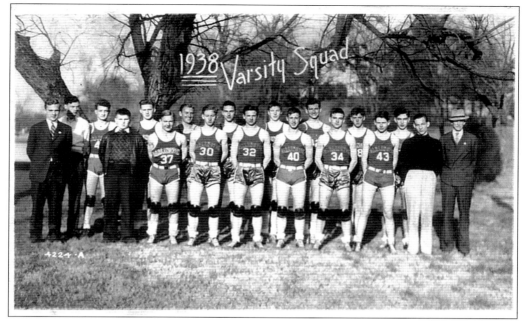

This real photo postcard pictures the 1938 varsity basketball squad of Darlington School for Boys. From left to right are the following: (front row) Dan Cooper, Audrey Tucker, Tom Jordan, Jim Bonds, Bill Warren, Jim Dempsey, James Montgomery, Ben Walker; (back row) Mark Lindsey, Harlan Starr, Dick Proctor, Billy Hackett, Edward Harris, Bobby Moore, Isaac Wright, Rutledge Summerville, Jim Todd, George Wells, and P.J. Weaver, coach.

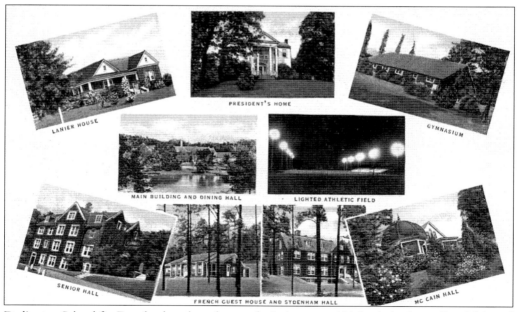

Darlington School for Boys has long been known for its beauty and high scholastic standing. This card features some of the buildings located on the campus including McCain Hall, Lanier House, and "Alhambra," the president's home. It was published by Wyatt Book Store in Rome.

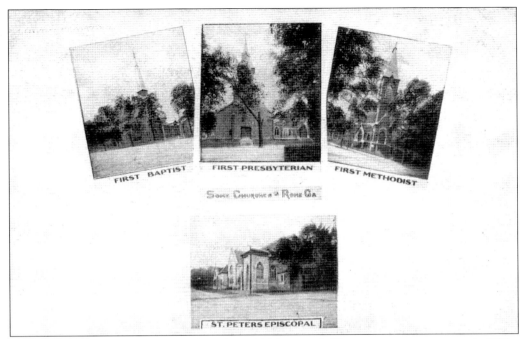

Some churches of Rome are featured on this *c.* 1915 postcard. The message on reverse reads, "Why not go out to the First Methodist Church with me Sunday morning? You ought to run away and come to Rome. It is fine. When may I expect you?"

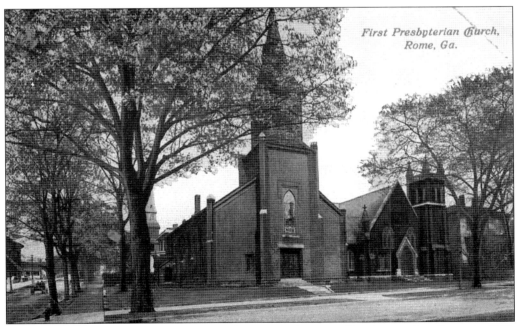

Organized in 1833 at Livingston, Georgia, The First Presbyterian Church moved to Rome in 1845. The church was dedicated in 1849 and its sanctuary dates back to 1854. During the Civil War the Union Army used the church for storage. It is located at 101 East Third Avenue.

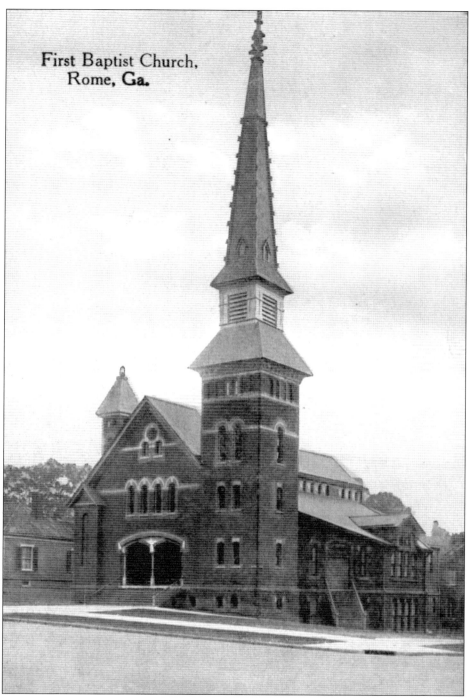

The First Baptist Church, located at the corner of East Fourth Avenue and East First Street, was established in 1835. Originally located at Eighth Avenue and West First Street, the church moved to its present site in 1855. A new and larger building was erected in 1883 and was used until 1958 when the present sanctuary was dedicated.

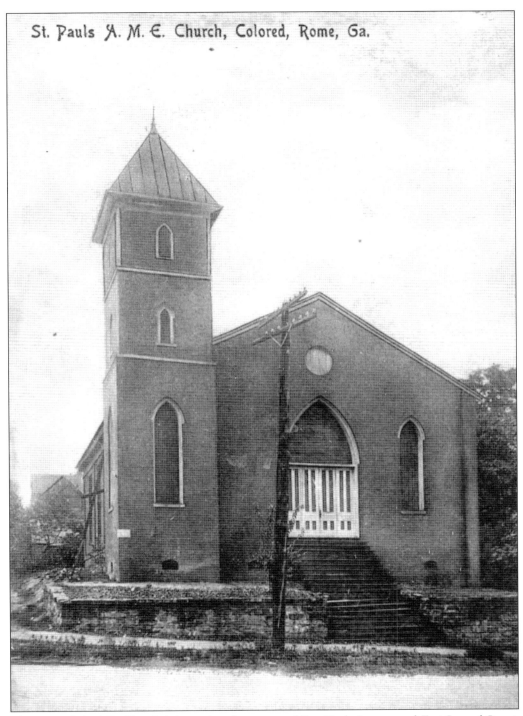

The St. Paul A.M.E. Church is located at the corner of East Sixth Avenue and East Second Street. Originally a wooden structure built around 1840, the building was replaced in 1852 by a brick building and used as the Methodist Church. It was sold to the A.M.E. congregation in 1884.

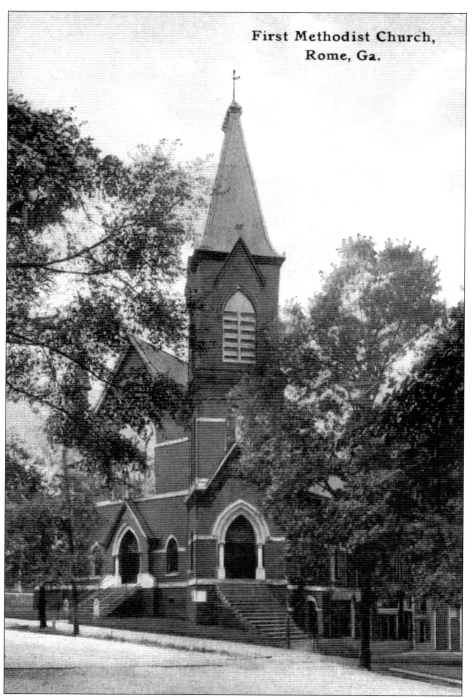

Established in 1840, the First United Methodist Church of Rome was first located on Eighth Avenue. Their second home was at the corner of East Second Street and Sixth Avenue. The present-day Gothic Romanesque structure is today located at 202 East Third Avenue. The property was purchased in 1880 and opening services began in 1888.

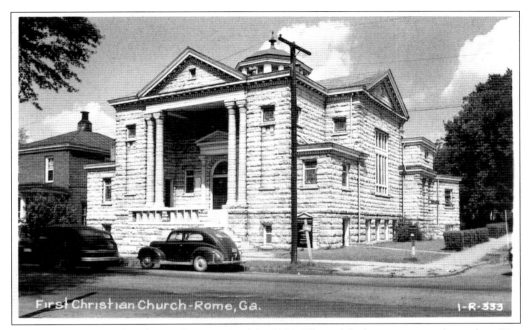

The First Christian Church was first organized in 1896. The original structure was located on East Third Street and was used until 1912. The present-day structure at 209 East Second Avenue was erected in 1912 using marble donated from the Tate Quarry in Tate, Georgia.

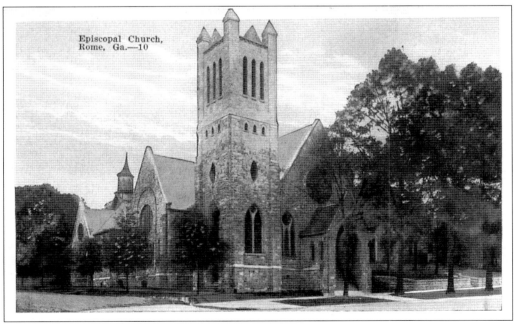

St. Peter's Episcopal Church, located at 101 East Fourth Avenue, was organized in 1844. It was originally located at the corner of Fifth Avenue and East First Street. This view from around 1915 shows the present-day church that was built in 1853.

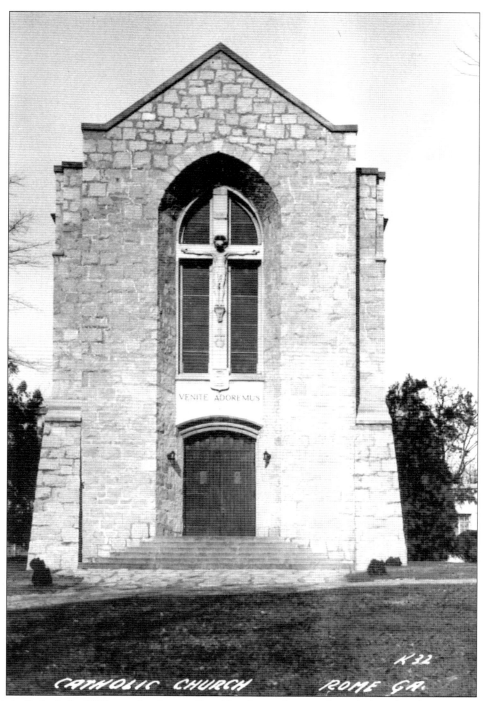

Originally built in 1868 on what is now East First Street, St. Mary's Catholic Church constructed a new church building at 911 North Broad Street in 1930. It was built using Stone Mountain granite. A large crucifix is carved in stone above the entrance. This real-photo card dates to about 1945.

Six
Streets and Bridges

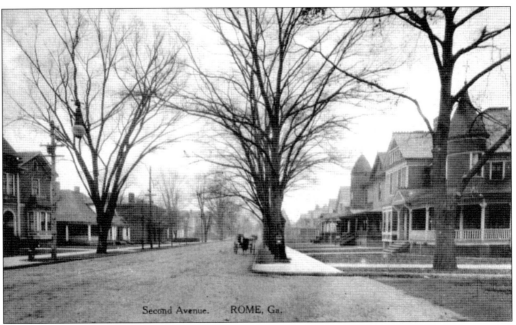

Postmarked August 12, 1911, this Albertype-view along East Second Avenue shows the residence of Isaac May in the right foreground. A prominent businessman, Isaac May served as one of Rome's early city commissioners. Under his term as chairman of the finance committee, Rome's first street paving was done.

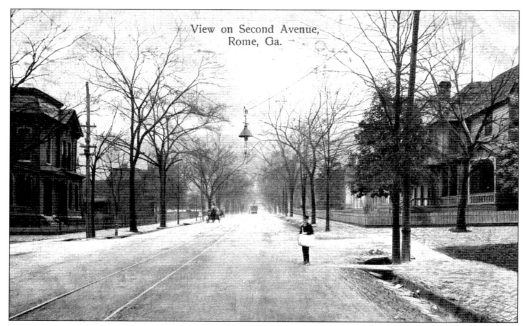

The postman stops briefly to smile for the photographer in this 1908 view on Second Avenue. Note the old streetlight in the center of card, as well as the trolley moving down the street. This section of Second Avenue today is mostly commercial.

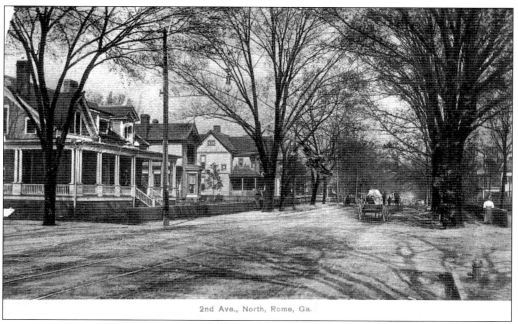

Horse-drawn carriages travel along North Second Avenue in a residential scene, postmarked 1907. The American News Company of New York published this 'Litho-Chrome' card.

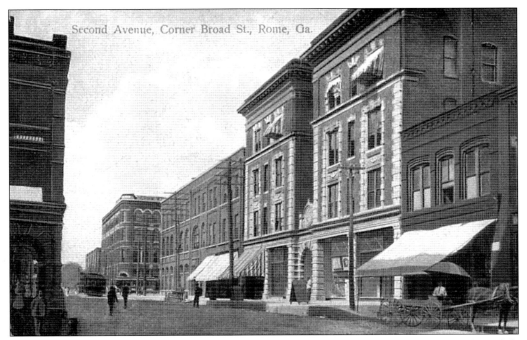

In this view of East Second Avenue looking north from East First Street, the Cherokee Hotel is at left, the West Buildings are at right center, and the Bass & Heard building is at left background. Bass & Heard were merchants of wholesale dry goods, notions, shoes, and hats.

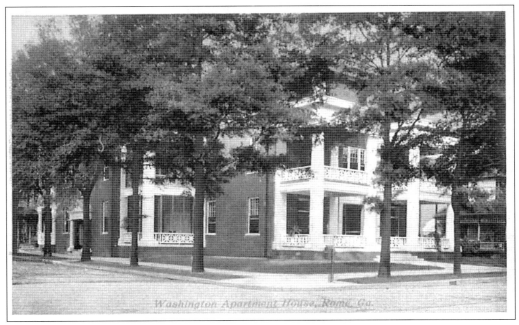

This white-border postcard from the 1920s shows the Washington Apartment House located at 201 East Second Avenue. One of Rome's finest apartment buildings at the time, by 1990 it had fallen into disrepair and was torn down.

The residence of ex-congressman Hon. John W. Maddox was located at 419 East Third Avenue. At one time John W. Maddox served as mayor of Rome, and as judge of Rome's Superior Court.

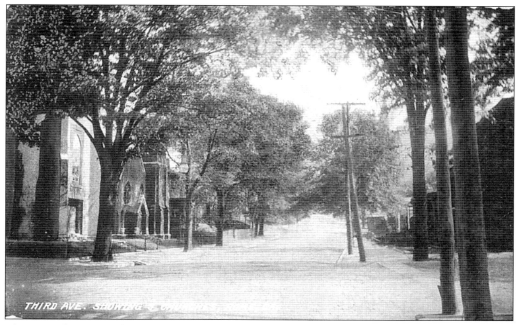

This view along East Third Avenue shows the First Presbyterian Church at the immediate left at 101 East Third. The First Methodist Church located at 202 East Third and the First Christian Church in its first home, located at 201 East Third, are obstructed by the trees. This postcard was published c. 1910.

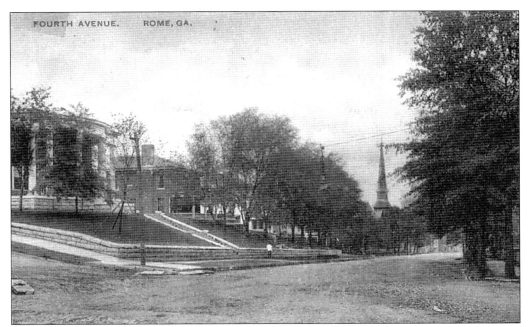

Taylor & Norton published this view of Mayor T.W. Lipscomb's residence located at 206 East Fourth Avenue. T.W. Lipscomb was mayor of Rome when the Nathan Bedford Forrest Monument and the Monument to the Daughters of the Confederacy were dedicated in 1909 and 1910.

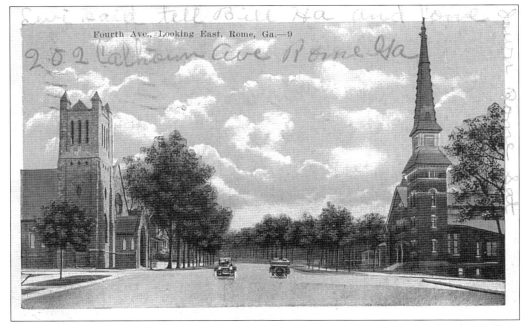

Two motorists pass by the St. Peters Episcopal Church at left and the First Baptist Church at right in this postcard view looking east along Fourth Avenue from Broad Street. This card was postmarked in 1925.

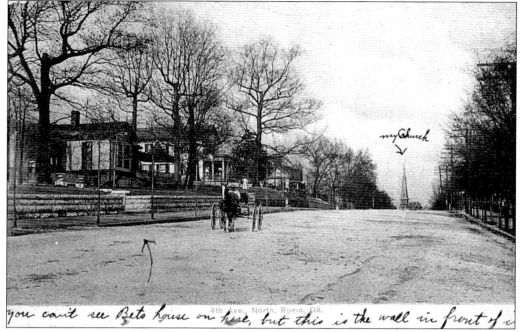

This postcard, mailed in 1907, shows the 300 block of Fourth Avenue with the steeple of the First Baptist Church in the distance. The sender has noted that she attends church at this location and that the photographer just missed including her friend's house in the picture.

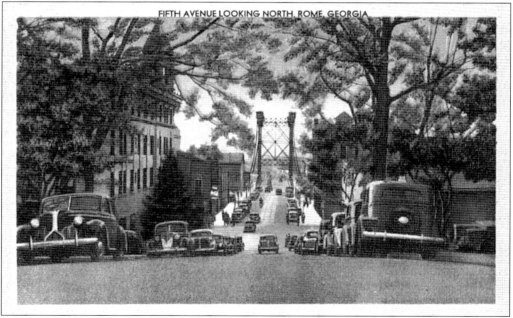

The metal towers of the old Fifth Avenue Bridge loom large in the background of this postcard from the 1940s. At left is The Hotel Forrest and the old Floyd County Courthouse steeple is visible through the trees. Elliott Sales of Rome published this postcard.

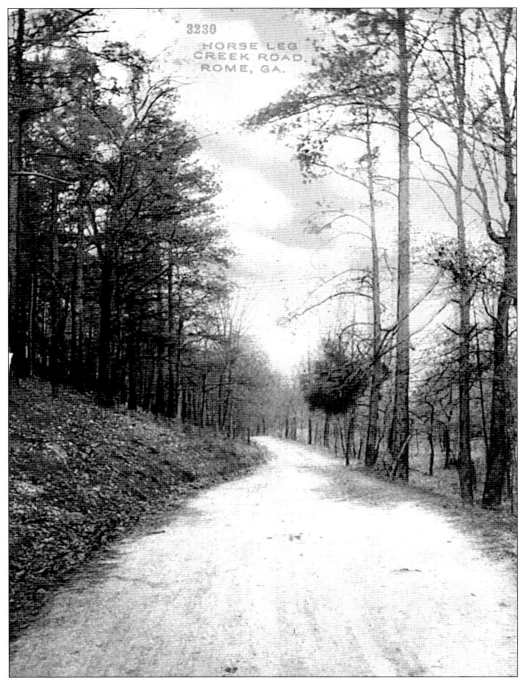

The Horseleg Creek Road area is home to the McLean Marshall Virgin Forest, the only National Landmark Forest in the United States that is located within a city's limits. Designated by the Department of the Interior as such, the forest contains 175 acres of wilderness, which was donated to the Nature Conservancy by McLean Marshall. This card was published c. 1910 by S.H. Kress & Company.

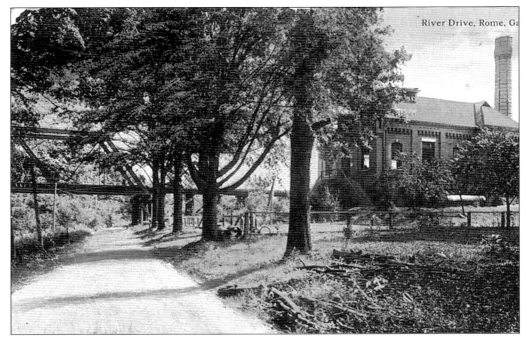

The old Oostanaula Pumping Plant's brick intake station, built in 1893, is shown here in 1911 along River Drive near Chieftain's Museum. Two steam-powered pumps delivered water to the top of Fort Jackson by way of a 16-inch cast-iron main.

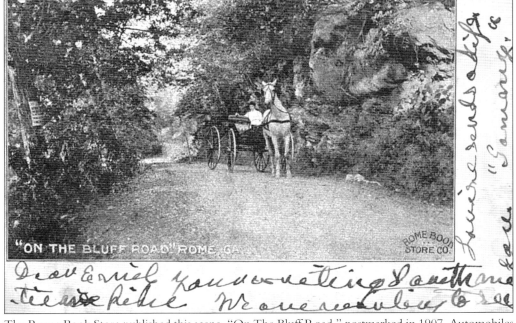

The Rome Book Store published this scene, "On The Bluff Road," postmarked in 1907. Automobiles were considered dangerous and unreliable in their early years, and most residents were satisfied with their horse-and-buggy rigs for transportation.

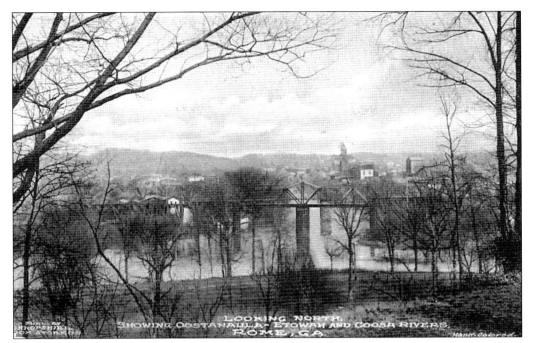

This hand-colored postcard looking across Rome's three rivers shows the sunrise over Rome c. 1910. The Central of Georgia Railroad trestle, and just above it, the Second Avenue Bridge cross the Oostanaula River. The old Floyd County Courthouse steeple is visible in the distance.

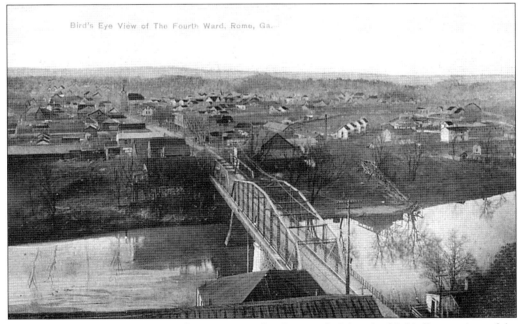

The Fifth Avenue Bridge is seen where it crosses the Oostanaula River in this bird's-eye view of the Fourth Ward taken from the top of the old courthouse in 1908. This bridge was built in 1888 after a flood destroyed the covered bridge in 1886.

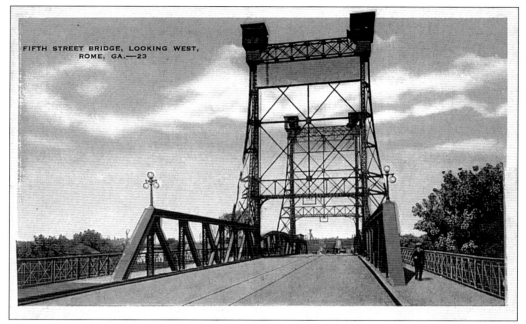

This 1925 postcard shows the Fifth Avenue Bridge—not Fifth Street Bridge—that was built in 1916. The tall metal towers of this drawbridge were torn down in 1943 and donated to the scrap drive to aid the armed forces in World War II. This bridge was replaced with the Colquitt Hall Bridge in 1980.

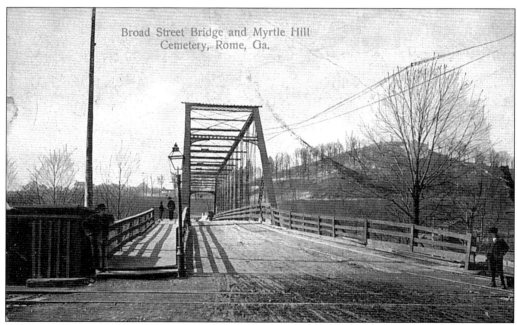

Built in 1886, this steel-structured bridge spanned the Etowah River until it was replaced with a new concrete bridge in 1916. It provided access to South Rome and Cave Spring. Myrtle Hill Cemetery can be seen in the background.

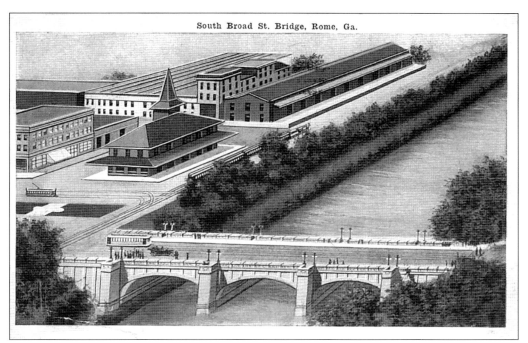

The new South Broad Street Bridge, as viewed from Myrtle Hill Cemetery, is shown in this artist's conception of how it would appear when it was completed. The Broad Street Depot, as well as Howel's Cotton Warehouse, is shown. This card is postmarked 1920, four years after construction of the bridge.

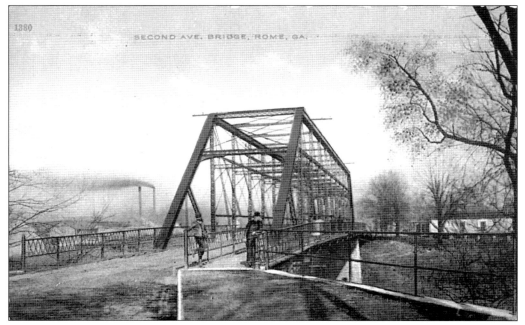

This postcard mailed in 1913 shows the Second Avenue Bridge crossing the Etowah River in East Rome. This bridge was replaced in 1915 with a new concrete structure.

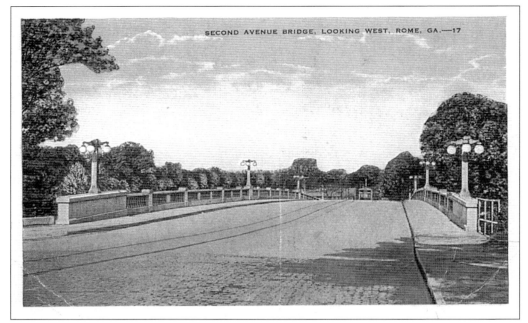

Construction began on the East Second Avenue Bridge over the Etowah River in 1915, and was opened to traffic in 1917. Pedestrians used a swinging footbridge until the bridge was completed. Brick paving can be seen across the bridge.

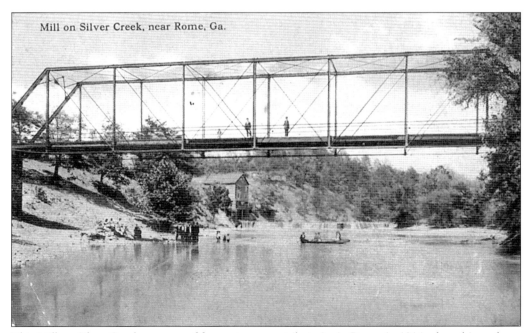

This Mill on Silver Creek was one of five waterpower tributaries in Rome in 1914 when this card was mailed. The steel structured railroad bridge seen here crossed the Etowah River above the site of today's Southeastern Mills on East First Avenue.

Seven
BERRY COLLEGE

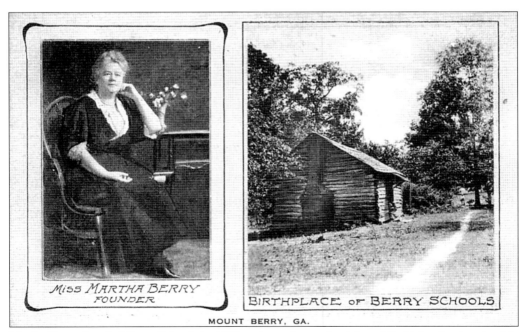

Martha Berry founded Berry Schools in 1902, a time when only eight public high schools existed in the state of Georgia. Although it was originally for boys only, a girl's division was started in 1911. This postcard pictures Miss Berry and the original log cabin in which she started the school.

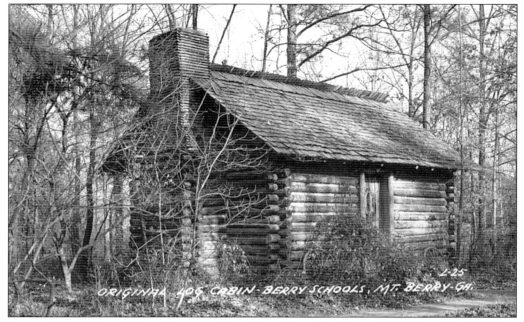

This photo postcard shows the original log cabin of Berry Schools, which now stands on the grounds at "Oak Hill." It was constructed in 1873 as a playhouse and a special retreat for Miss Berry in her childhood.

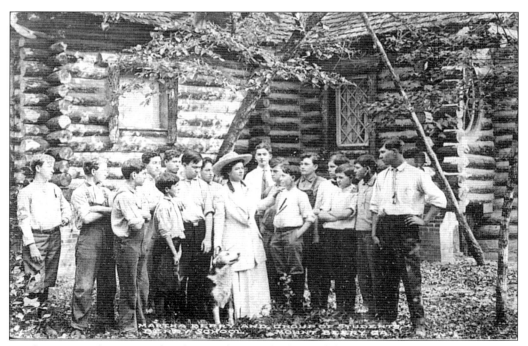

Martha Berry and a group of students gather on the lawn of the Roosevelt Cabin in this *c.* 1915 postcard. Miss Berry taught poor, mountain children of the rural South, realizing that they had very little opportunity elsewhere to receive an education.

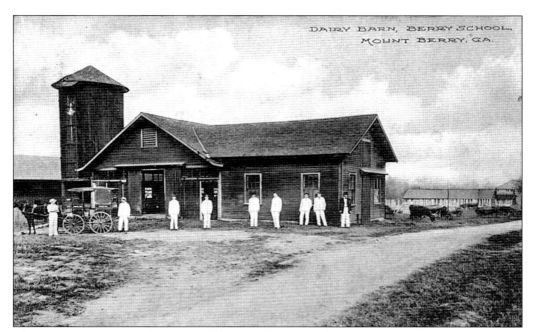

The Dairy Barn was erected in 1906 and by 1942 the Berry Schools operated one of the largest dairies in the country. This card postmarked in 1911 shows a group of dairy workers and some of the Jersey herd in the background.

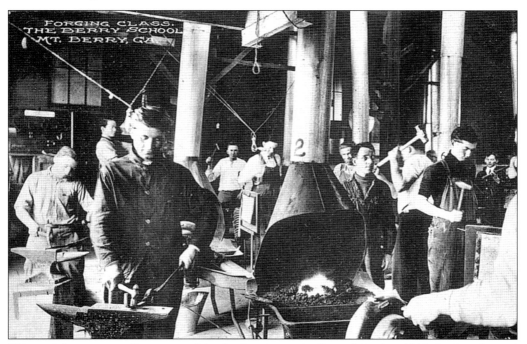

This card shows an excellent scene of the forging class at the Berry Schools *c.* 1915. Students learned basic skills of the trade and between classes put their skills to work in the construction of many buildings on the campus.

With more than 1,000 boys enrolled at the Berry Schools, more than 90 percent paid nothing in the way of cash for their tuition or their room and board. Students worked their way through school by working the grounds, preparing meals, and doing general maintenance on buildings.

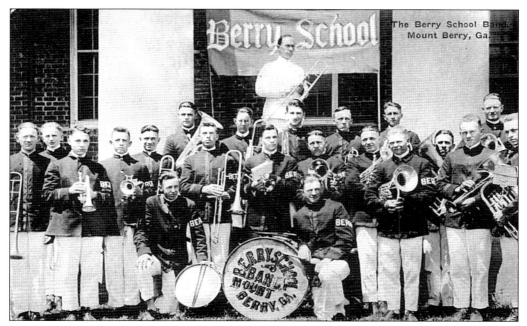

As enrollment increased at Berry, extracurricular activities were added for the enjoyment of the students. The Berry Schools Band is pictured on this card from about 1915. Martha Berry's motto was, "Whether at work or at play, do your best."

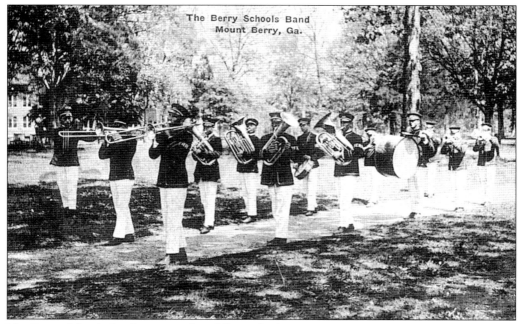

The Berry Schools Band is pictured in full parade dress in the postcard *c.* 1915. Today the Berry College Music Program offers courses to enrich the musical lives of Berry students as well as the entire community.

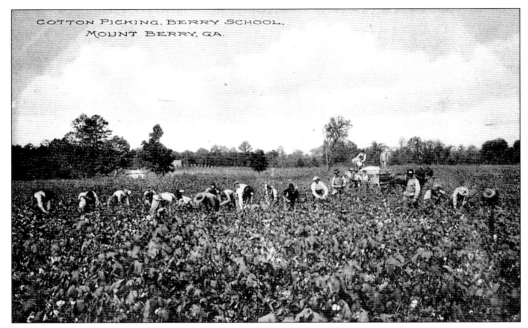

Picking cotton was another way students worked for their tuition, as seen on this postcard on the Berry School campus. Originally an 83-acre campus, Berry College is now over 28,000 acres and the largest college campus in the world.

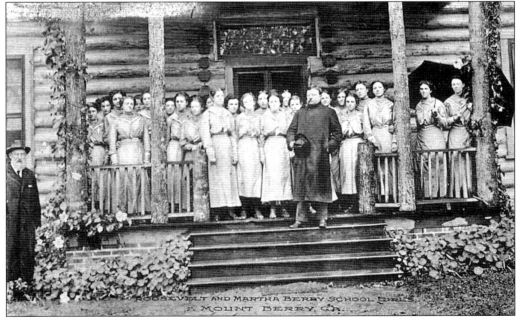

The Berry School was originally started for boys only. President Theodore Roosevelt convinced Martha Berry to start a girls division of the school. This card shows the President on his visit to the school in 1911. He is pictured with some of the students on the steps of the Roosevelt Cabin, which was named for him.

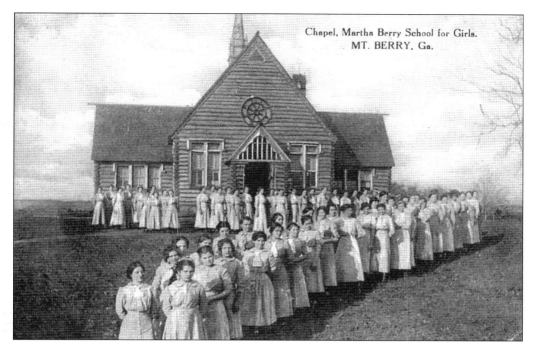

The Barnwell Chapel was built in 1911 and named for its architect Capt. John Barnwell. It was used for Sunday school and Sunday evening vesper services. Through the years it has been a popular site for weddings, used as a study hall, a library, and at one time it was used as a store.

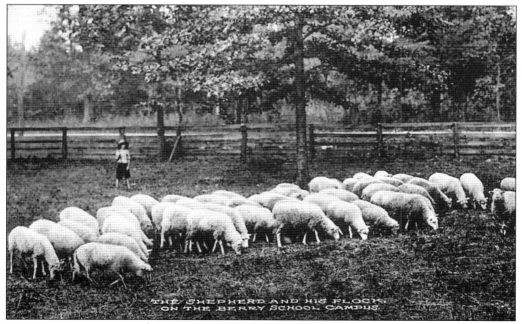

This vintage card pictures a shepherd with his flock of sheep on the Berry School campus. The wool would be used for weaving handicrafts such as rugs, floor coverings, bedspreads, and blankets. The handicraft shop is now located in the Hoge Building.

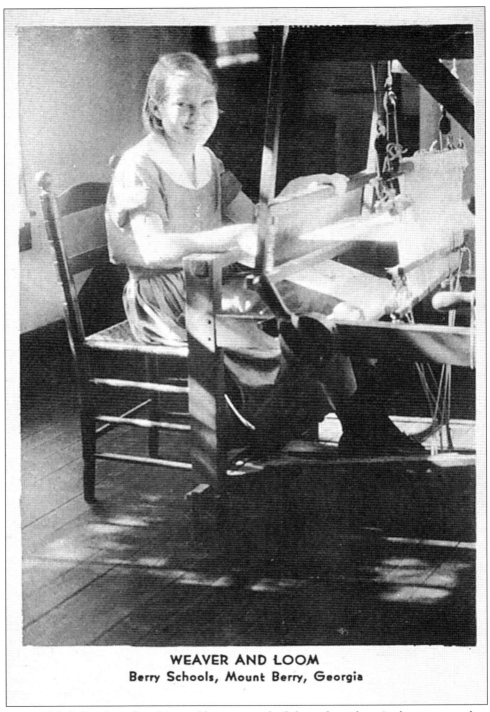

WEAVER AND LOOM
Berry Schools, Mount Berry, Georgia

Looms modeled after those found in rural homes were built by male students in the carpentry shop at Berry. To help support the school, handicrafts made on these looms were sold. A young female student is pictured at her loom in this card published around 1925.

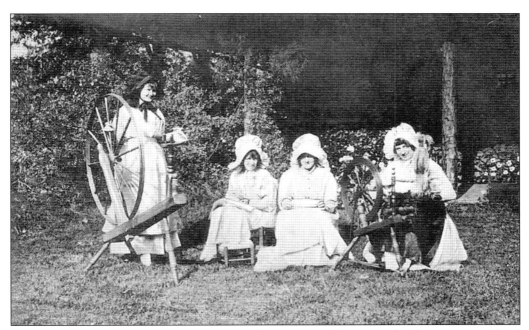

This group of girls were enrolled in the handicrafts operation at the Berry School. Spinning wool and flax raised on the Berry campus was one way these girls paid their tuition. Weaving continues today on some 14 student-made looms in the handicraft shops.

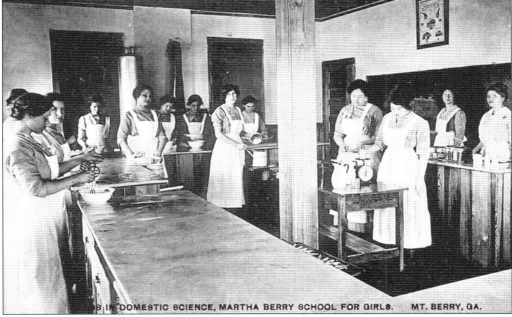

The domestic science class at the Martha Berry School for Girls is shown on this early postcard. Today Berry College has a co-educational, fully accredited science program and is recognized as one of the outstanding colleges in the South.

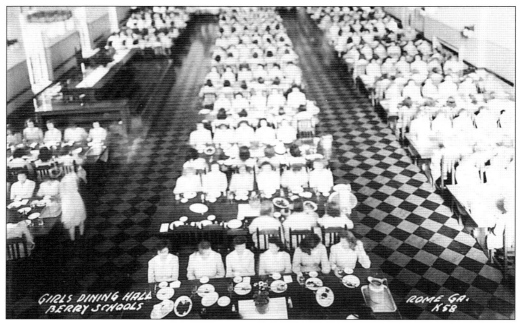

The girls dining hall, located in the Ford Building, is pictured in this real-photo postcard from around 1940. Henry and Clara Ford donated the solid oak table and chairs, as well as the silverware and china. This area has not been used as a dining hall since 1978.

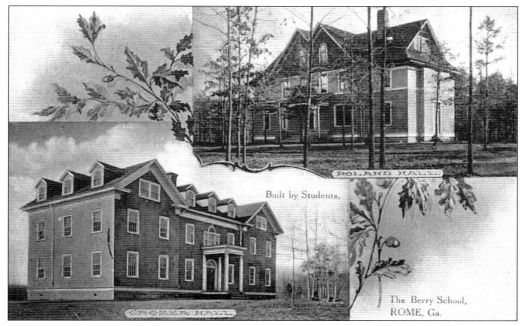

This dual-view card shows Crozer Hall and Poland Hall, both built by students of Berry Schools. Crozer Hall was built in 1909 and burned in 1927. This postcard was postmarked in 1910.

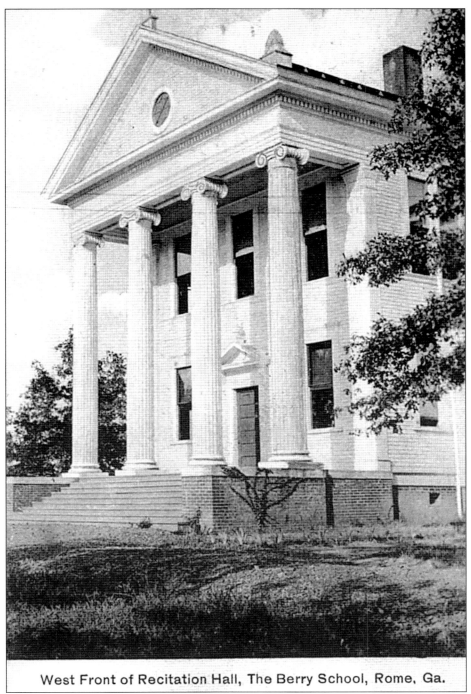
West Front of Recitation Hall, The Berry School, Rome, Ga.

Constructed in 1905, Recitation Hall is one of the oldest buildings on the Berry campus. It was built by students and had five classrooms and the principal's office on the first floor. The auditorium and library were on the second floor. Named for the schools first comptroller E.H. Hoge in 1960, it now houses the handicrafts operation. This photo was taken *c.* 1908.

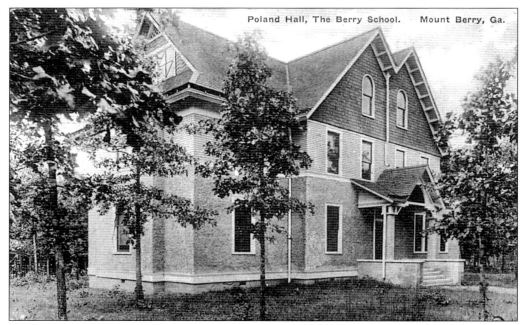

Poland Hall was built in 1907 as a dormitory, with funds contributed when Martha Berry spoke at Poland Springs, Maine. It was used as a dorm until the 1930s. It was remodeled into faculty/staff apartments, and is now a three-family residence.

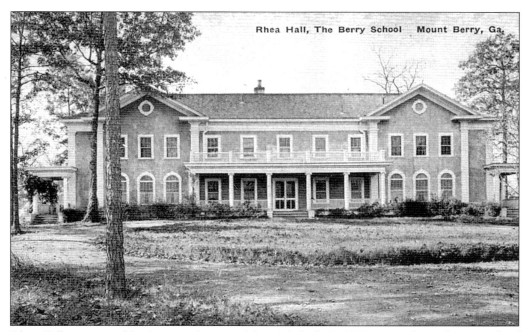

Rhea Hall was a combination guesthouse and hospital, built in 1912. It was located just north of Blackstone Hall. This building later became a residence for faculty women and even later, remodeled into apartments. It burned in 1941.

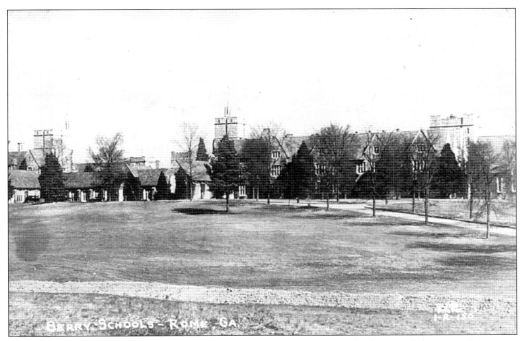

The Ford Building complex was a gift to Berry College by Henry and Clara Ford, however it was not called the Ford Buildings until the 1980s. He did not wish to be recognized and this request was honored until many years after his death.

Constructed in 1937 for science and agricultural studies, the Cook Building was named for S.H. Cook, longtime dean and twice-acting president of Berry College.

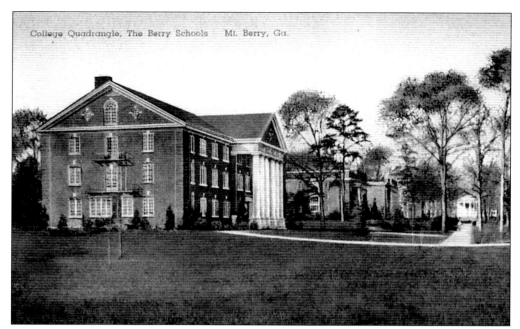

The College Quadrangle is pictured on this card c. 1935. These buildings were constructed during the 1920s and 1930s using brick made by the students at the school's brick plant, which was located in west Rome.

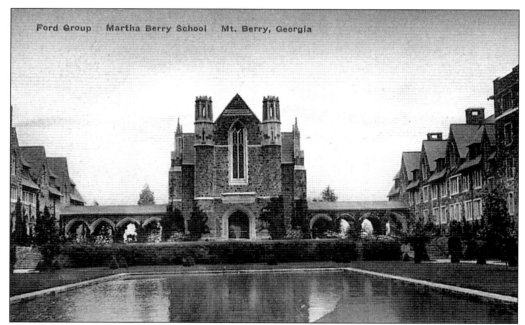

This hand-colored Albertype postcard shows the Ford Dining Hall in 1937. It was completed in 1925 and was modeled after the dining hall at Christ College at Oxford, England. With the completion of the cafeteria in the Krannert Center in 1978, it was discontinued as a dining hall and is now used for social functions such as dances and dinners.

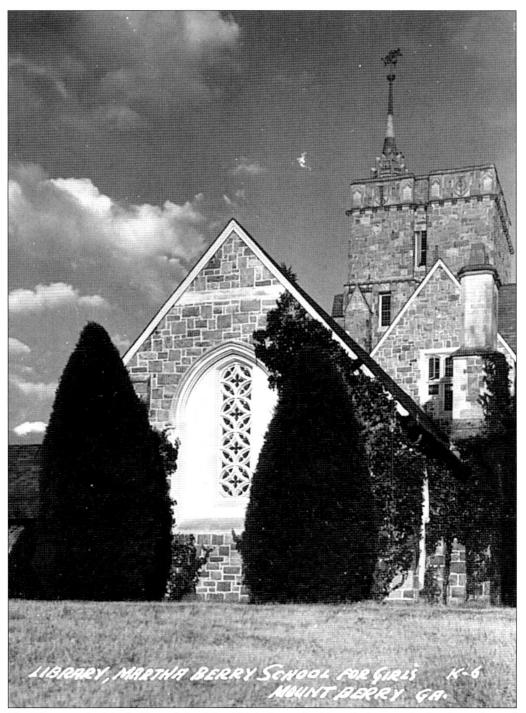

The Library at the Martha Berry School for Girls is shown in this real-photo card when it was located in the Ford Complex. The Memorial Library built in 1926, now houses the books, periodicals, archives, documents, and an on-line computer system.

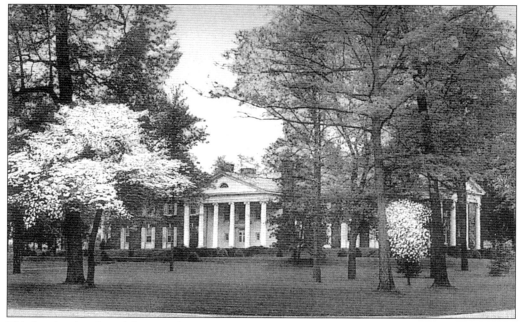

This hand-colored card features the Mothers' Memorial Building c. 1940. The girls' dormitory was built between 1930 and 1931 using funds from donors who contributed money in honor of their mothers. Now the south wing of Evans Hall, it houses faculty offices and several laboratories and classrooms.

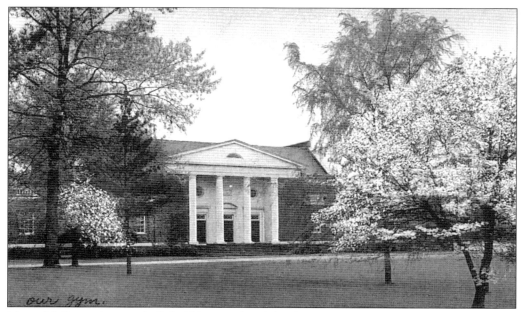

Memorial Gymnasium was built in 1937. It replaced the old wooden structured Pentecost Gymnasium that had been built in 1911. The gym was renovated in 1986 with funds from the Roy Richard's estate and was renamed The Roy Richard's Memorial Gymnasium. This postcard was postmarked 1941.

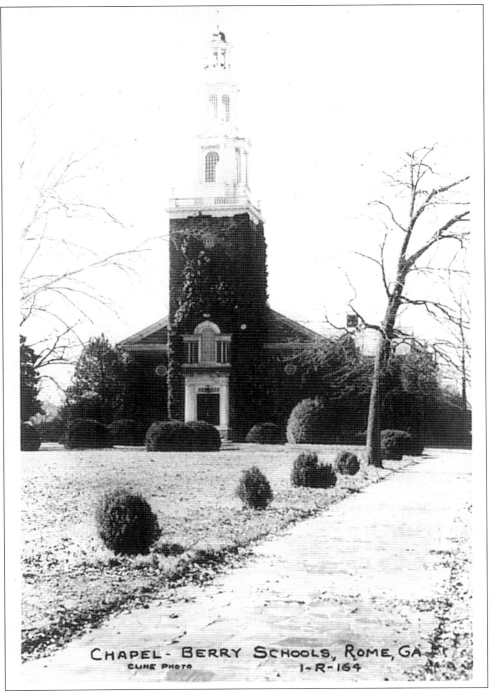

The 105-foot Berry College Chapel, built in 1915 by Berry College students, was modeled after Christ Church in Alexandria, Virginia. Originally seating 750, its capacity was increased to accommodate 1,100 people between 1927 and 1928. It was completely renovated in 1997. Martha Berry is buried on the south lawn of the chapel.

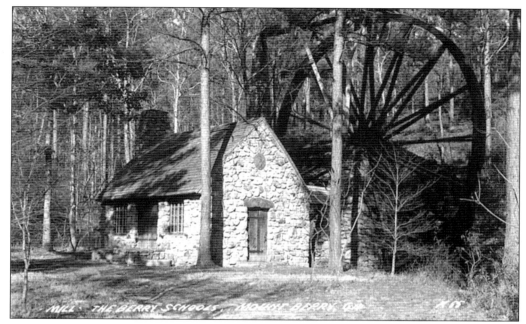

The Old Mill, built in 1930, has one of the largest overshot waterwheels in the world. It is 42 feet in diameter and was built by Berry students. Republic Mining and Manufacturing Co. of Hermitage, Georgia, donated the iron hub. The mill, used to grind corn into meal and grits, still operates on special occasions.

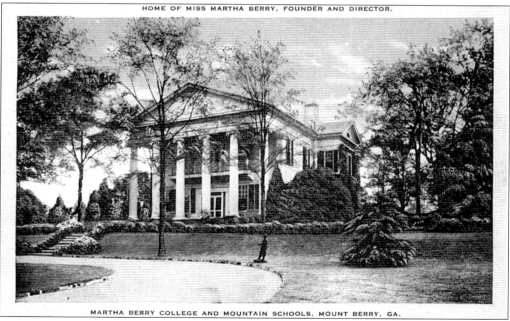

"Oak Hill," the home of Miss Martha Berry, founder and director of Berry College, is shown in this 1920s view published by the E.C. Kropp Company. Thomas Berry purchased the property in 1871 and built the house around 1875.

Eight
LINDALE

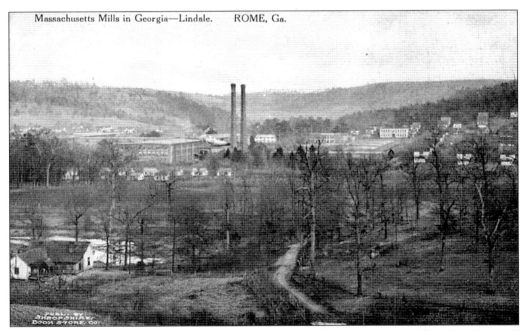

Lindale Cotton Mills began operations in 1896 as Massachusetts Cotton Mills. The Pepperell Manufacturing Company purchased it in 1926. In 1965 it merged with West Point Manufacturing and became West Point Pepperell. This card is hand-dated 1907.

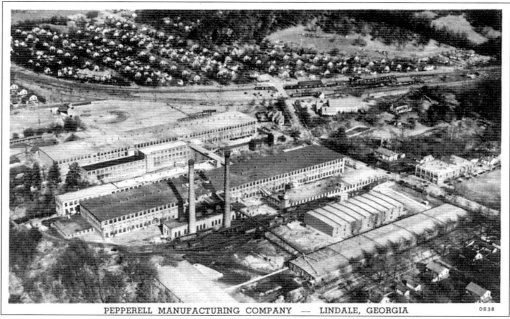

This aerial-view postcard shows Pepperell Manufacturing Company around 1956. Visible upon close inspection are the Lindale Hotel, the Lindale Inn, the baseball field, and the Southern Railway Depot. Butler Airphotos of Cleveland, Ohio took this photo.

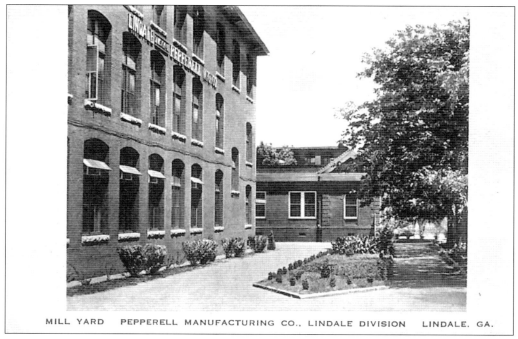

A mill office was built near the southern bank of Silver Creek in 1902. This card shows a portion of the mill yard and the landscaped offices, as they appeared about 1945.

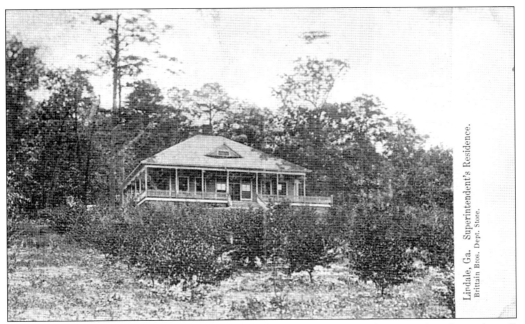

Known locally as "Red Top," this house was built for the mill superintendent. It sat just above the mill agent's house. This card is postmarked August 19, 1907.

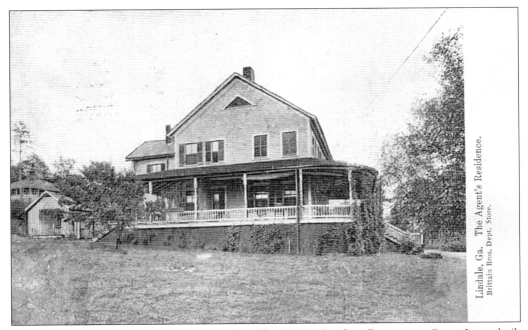

This view of the agent's residence was distributed by Brittain Brothers Department Store. It was built for the mill agent, but besides Mr. H.P. Meikelham, no other agent ever resided here. After his death it was used as a guesthouse for out-of-town visitors.

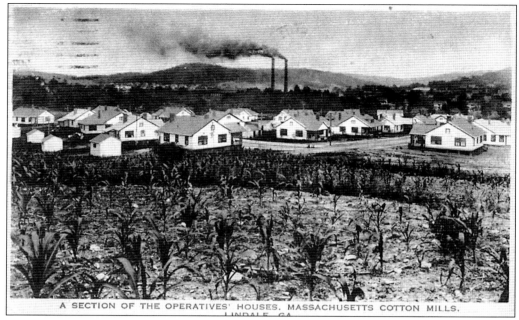

This hand-colored view shows a section of the Operatives' Houses located in the Jamestown area of Lindale, around 1925. Jamestown included Central, Crescent, and Terrance Avenues, and South Second Street.

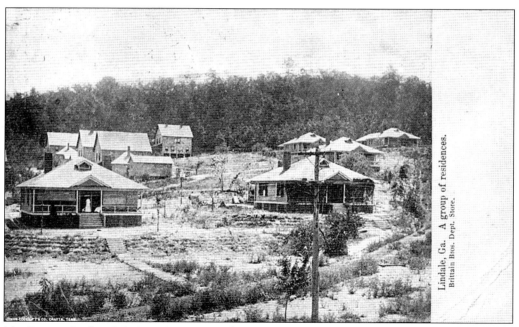

MacGowan-Cooke Printing Company of Chattanooga, Tennessee, published this view of Lindale residences. It was distributed by Brittain Brothers Department Store and is postmarked August 1, 1907.

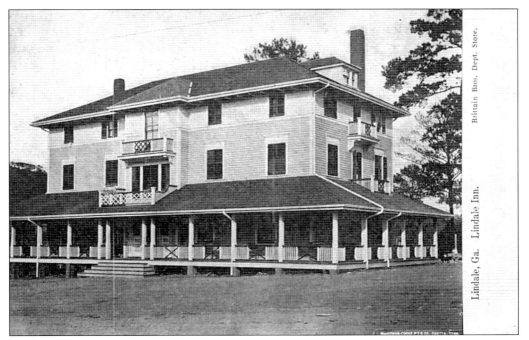

The Lindale Inn was a three-story structure built in 1903. The inn was used to house officials of the Cotton Mill until it closed in 1951. It continued to be used as office space until maintenance costs became a financial burden and it was torn down in 1959.

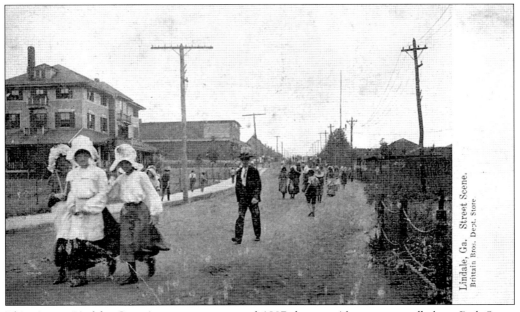

This vintage Lindale, Georgia street scene around 1907 shows residents on a stroll along Park Street near the Mill. Sunday afternoon walks were a favorite past time by the residents of Lindale. The three-story Lindale Inn is in background at left.

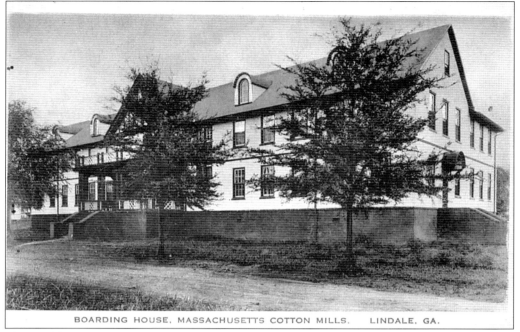

BOARDING HOUSE, MASSACHUSETTS COTTON MILLS. LINDALE, GA.

The Lindale Hotel, also known as the Boarding House, is pictured here about 1925. It was built in 1920 with 56 rooms, 43 of which were rental rooms. It closed as a hotel in 1961 and was later used as a home for retired persons. It was torn down in 1966.

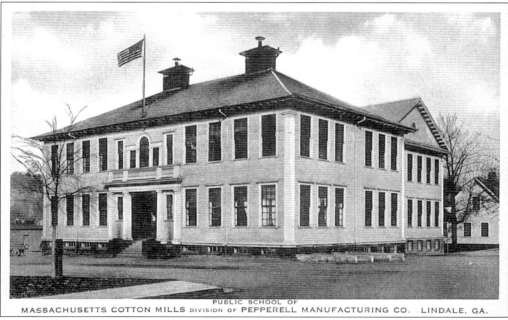

PUBLIC SCHOOL OF
MASSACHUSETTS COTTON MILLS DIVISION OF PEPPERELL MANUFACTURING CO. LINDALE, GA.

The Albertype Company of New York published this view around 1930 of the Public School of the Massachusetts Cotton Mill, by now a division of Pepperell Manufacturing Company. It was built in 1902, and the annex was added in 1920.

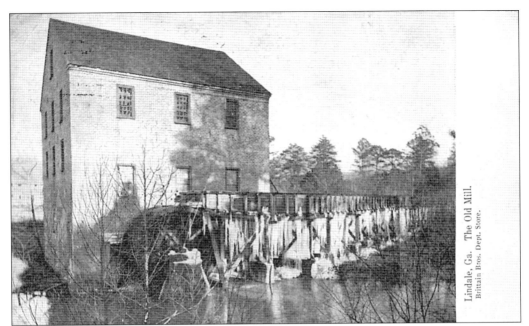

Larkin Barnett erected the historic Old Mill on the bank of Silver Creek around 1832. It was restored in 1972 and placed on the National Register of Historic Places on September 9, 1993.

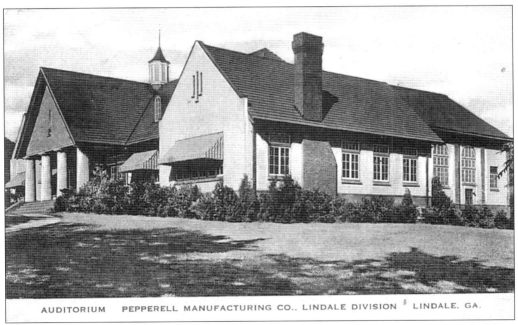

The Lindale Auditorium opened on May 14, 1921. It provided such amusements as a pool table, a swimming pool, reading room, ladies social room, tearoom, a library, and a theatre. The 21,783-square-foot building was donated to the First Baptist Church by West Point Pepperell and is now used as their Christian Life Center.

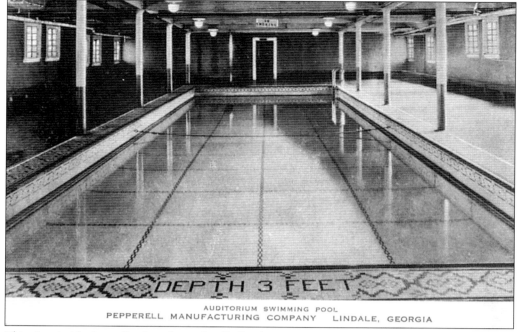

This view inside the auditorium shows the tile-lined swimming pool, which was very popular with the children of Lindale. This Albertype postcard is postmarked 1950.

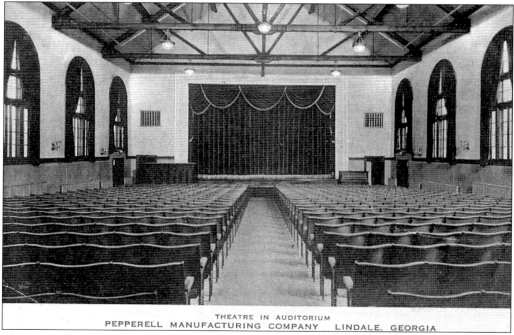

The auditorium also contained a theatre as shown on this card from the 1940s. Pictures were shown every night at 7 p.m. and every Sunday at 2 p.m. The auditorium closed at 6 p.m. on Sundays so there was no conflict with church services.

Nine
CAVE SPRING

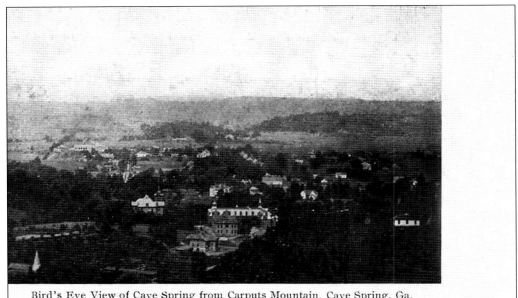

Bird's Eye View of Cave Spring from Carputs Mountain, Cave Spring, Ga.
Pub. by J. W. Seitz.

Published by J.W. Seitz and postmarked in 1907, this postcard offers a bird's-eye view of the village of Cave Spring, Georgia, from Corput's Mountain (misspelled Carput's). The sender of this card marked the location of his or her home with an 'X' at the center.

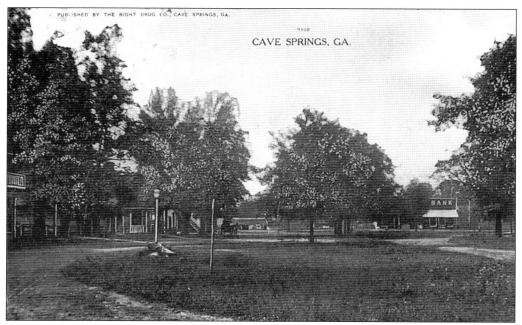

The city of Cave Spring, located about 16 miles southwest of Rome, Georgia, was incorporated on January 22, 1852. The Right Drug Company of Cave Spring published this early view of the downtown area in 1909.

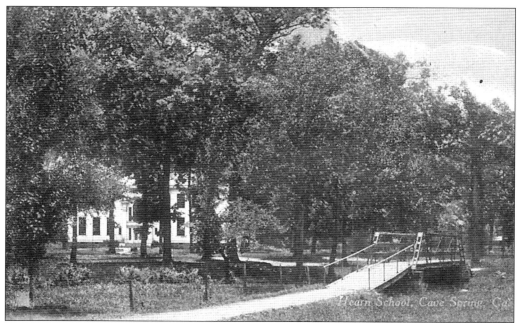

Hearn School, originally named Lott Hearn Manual Labor School, was incorporated by Act of the Legislature in 1839. Founded by the members of the Cave Spring Baptist Church, it was named for Lott O. Hearn who bequeathed an endowment of $12,500.

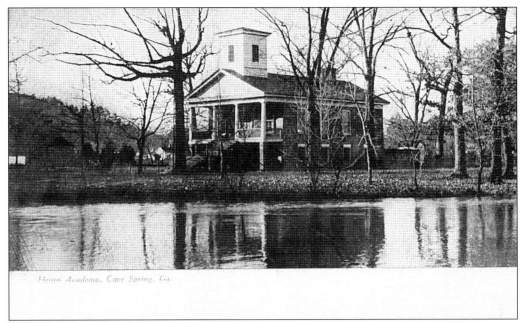

In 1903 the Georgia Baptist Convention acquired Hearn School and gradually dropped the "Manual Labor" portion of the name. It was recognized as a college preparatory school and the name was changed to Hearn Academy.

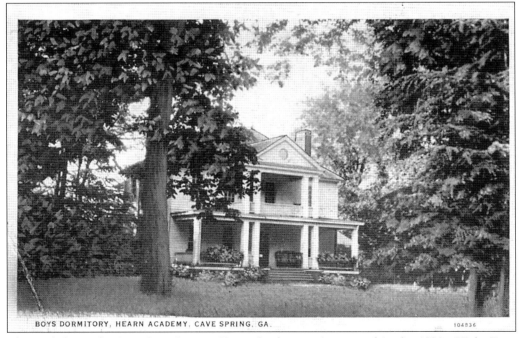

This card shows the Boys Dormitory at Hearn Academy as it appeared in the 1920s. Hight Drug Company of Cave Spring, Georgia, published this card.

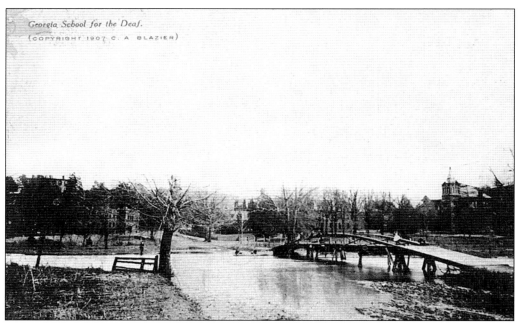

The Georgia School for the Deaf was established in 1847 under the direction of Mr. O.P. Fannin, then principal of the Hearn School. Mr. Fannin served as principal until 1858.

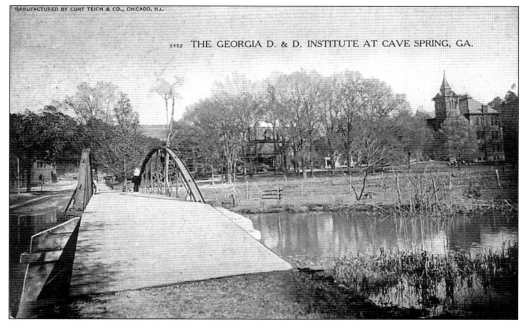

The Georgia D & D Institute At Cave Spring, Georgia, was built on nearly eight acres of land and provided education for the deaf children of Floyd County. This school was strictly for deaf children and was not a charitable institution or an asylum, as the title of this card would suggest.

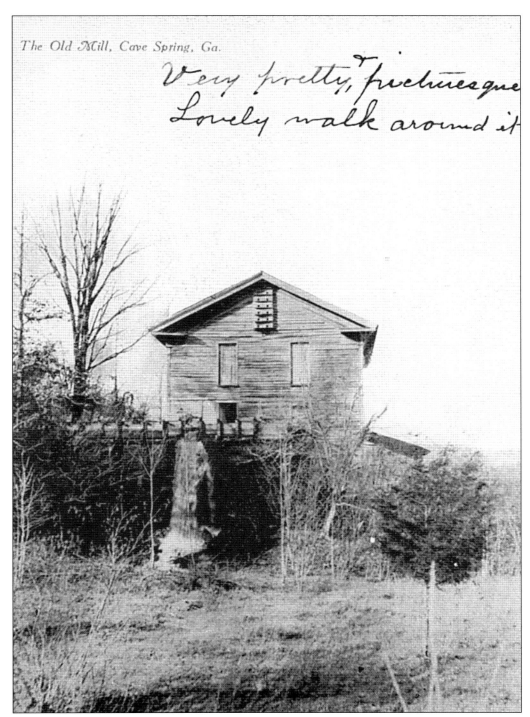

The Old Mill in Cave Spring, near Little Cedar Creek, dates back as early as 1841. Through the years it has been known as Richardson Mill, Harper Mill, and Carroll Mill. Tom Jones Publishing Company printed this view *c.* 1910.

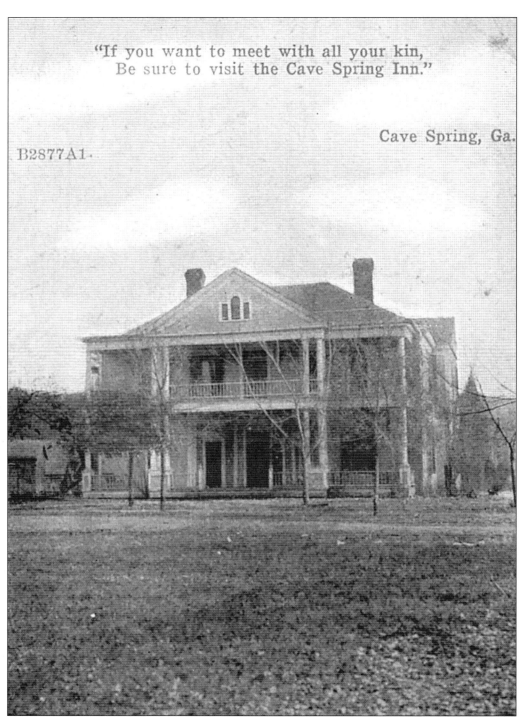

The two-story Cave Spring Inn used the catchy slogan, "If you want to meet with all you kin, Be sure to visit the Cave Spring Inn." H.G. Zimmerman & Company of Chicago, Illinois published this postcard around 1910.

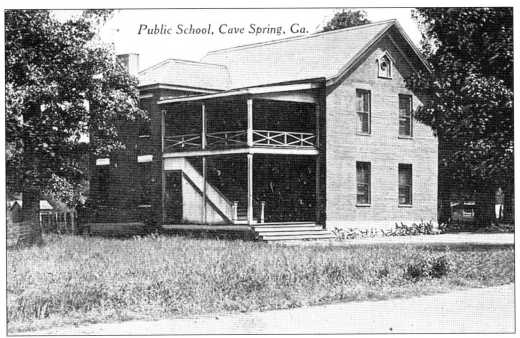

Cave Spring Drug Store published this view of the Public School Building which is postmarked 1920 with the message: "I would have written sooner but I have been picking berries and going in bathing."

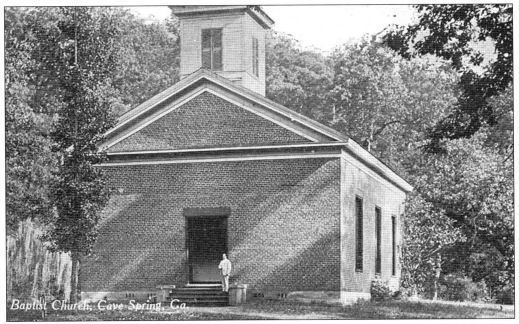

Historic Cave Spring Baptist Church is pictured in this postcard sent in 1920. This church building was erected in 1851 using hand-made brick, 15 years after it was established in 1836. Until 1851, services were held in the Hearn School.

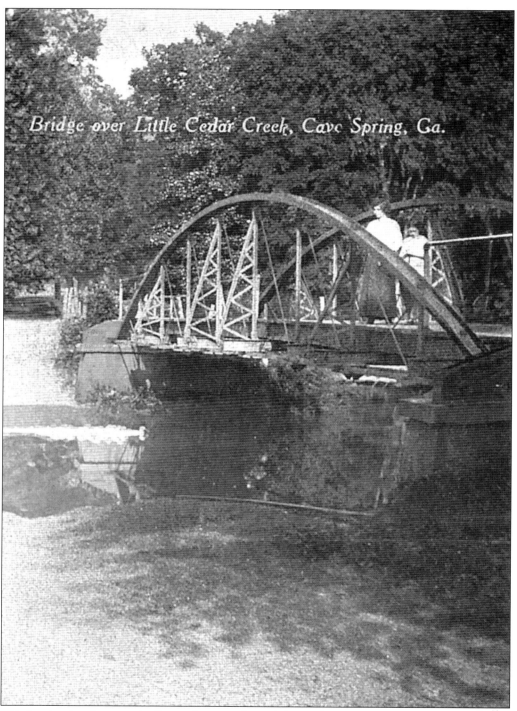

This hand-colored postcard offers a close up view of the Bridge over Little Cedar Creek in Cave Spring, Georgia. Little Cedar Creek is used for fishing, swimming, and boating and runs the entire length of the town. This card was published by Cave Spring Drug Store *c.* 1910.

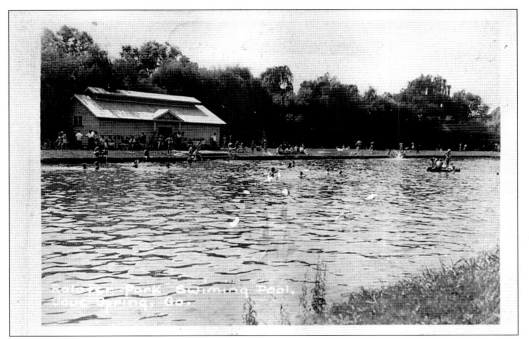

The swimming pool at Rolater Park in Cave Spring is the focus of this real-photo postcard. Rolater Park is situated on 29 acres of land, which was donated by Dr. Joseph B. Rolater in October of 1931. The park also includes a cave, a spring, and a lake.

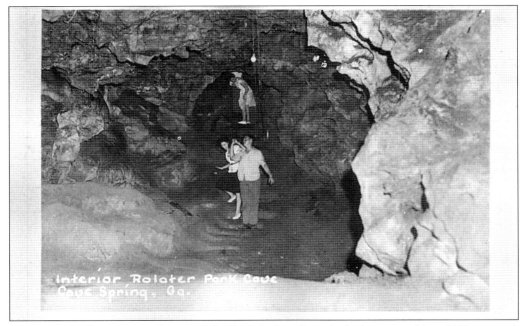

A view inside the cave at Rolater Park in Cave Spring, Georgia, is shown on this *c.* 1950 postcard. Decorated with stalactites and stalagmites, this subterranean cavern is visited by thousands annually as a scenic wonder.

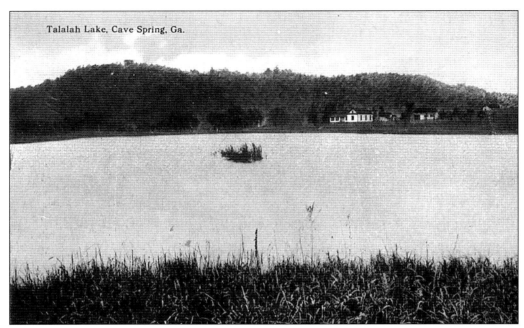

Located on the western edge of the valley in Cave Spring is Talalah Lake. This lake, along with Woodstock Lake, covers about 15 acres and is fed entirely by springs of carbonated water. J.C. Reeves of Cave Spring, Georgia published this *c.* 1915 postcard.

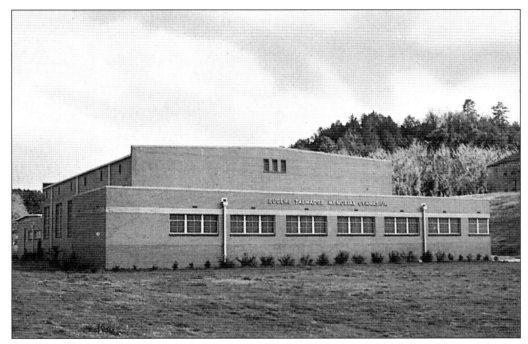

The Eugene Talmadge Memorial Gymnasium in Cave Spring was erected in memory of the late Governor Talmadge on the campus of the Georgia School for the Deaf. John L. Scarbrough of Rome, Georgia published this Ektachrome card.